now you're cookin'
TUSCANY

Colophon

© 2003 Rebo International b.v., Lisse, The Netherlands

This 3rd edition reprinted in 2006.

Original recipes and photos: © Ceres Verlag, Rudolph-August Oetker KG, Bielefeld, Germany

Design and layout: Minkowsky Graphics, Enkhuizen, The Netherlands

Cover design: Minkowsky Graphics, Enkhuizen, The Netherlands

Translation: American Pie, London, UK and Sunnyvale, California, USA

ISBN 13: 978-90-366-1483-2

ISBN 10: 90-366-1483-X

now you're cookin'
TUSCANY

THIS BOOK JUST MAKES YOU WANNA COOK

REBO
PUBLISHERS

Foreword

La cucina Toscanese is "semplice," simplicity being its greatest asset.

Produce in Italy is very fresh and of excellent quality. Combined with Italian

passion, this makes Tuscan dishes finger-licking good.

Thanks to this simplicity, the dishes can easily be made anywhere

in the world. You can make your own pesto or tagliatelle with seafood

in no time at all.

Tuscan cooking is renowned for its use of game such as rabbit haunch with

olives or hare in tomato sauce, but you can substitute other meats, such

as Rock Cornish hen, if game is not available. For people with a sweet

tooth there are delicious desserts such as florentines or figs in orange

sauce. Buon appetito!

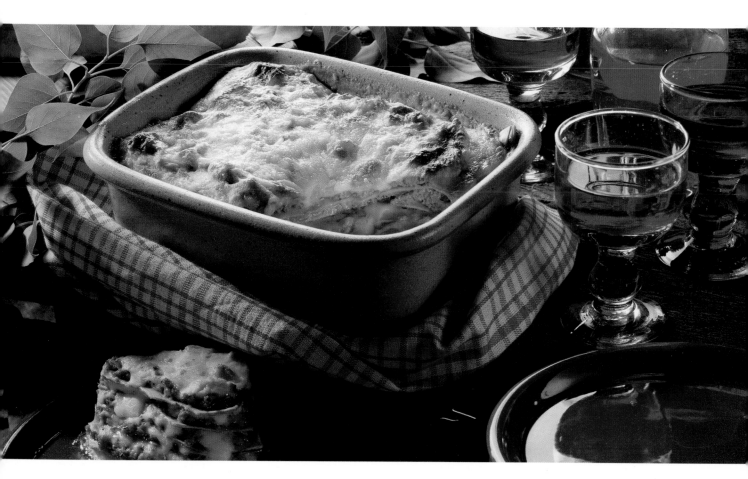

Abbreviations

tbsp = tablespoon

tsp = teaspoon

oz = ounce

lb = pound

°F = degrees Fahrenheit

Method

Rub a skillet with a clove of garlic. Peel and chop the onion. Heat oil in the pan and sauté onion. Add ground beef and brown. Add the tomato paste and simmer. Season with salt, pepper, rosemary, oregano, and thyme. Add the broth and simmer for a few minutes. Mix crème fraîche, milk, and Parmesan cheese.

Place layer of lasagna in a buttered baking dish. Cover with the meat sauce, and repeat, making alternate layers. The top layer should be meat sauce (the noodles should be completely covered). Dot with butter and top with cheese mixture. Place in the oven.

Oven Temperatures

Conventional oven: 400-425°F (preheated)

Fan-assisted oven: 175-400°F (preheated)

Gas oven: Mark 4 (preheated)

Cooking time: around 35 minutes

Tip

Stir 4-5 skinned, chopped tomatoes into the sauce.

Lasagne al forno

Ingredients

1 garlic clove, peeled, 1 large onion

1 tbsp oil

½ cup ground beef, ½ cup ground pork

3 tbsp tomato paste

salt and freshly ground pepper

pinch of dried rosemary

pinch each of dried oregano and dried thyme

1 cup meat broth

⅔ cup crème fraîche

½ cup milk

3 tbsp grated Parmesan cheese

8 oz package lasagna, 3 tbsp butter

Serving suggestion

Tomato salad

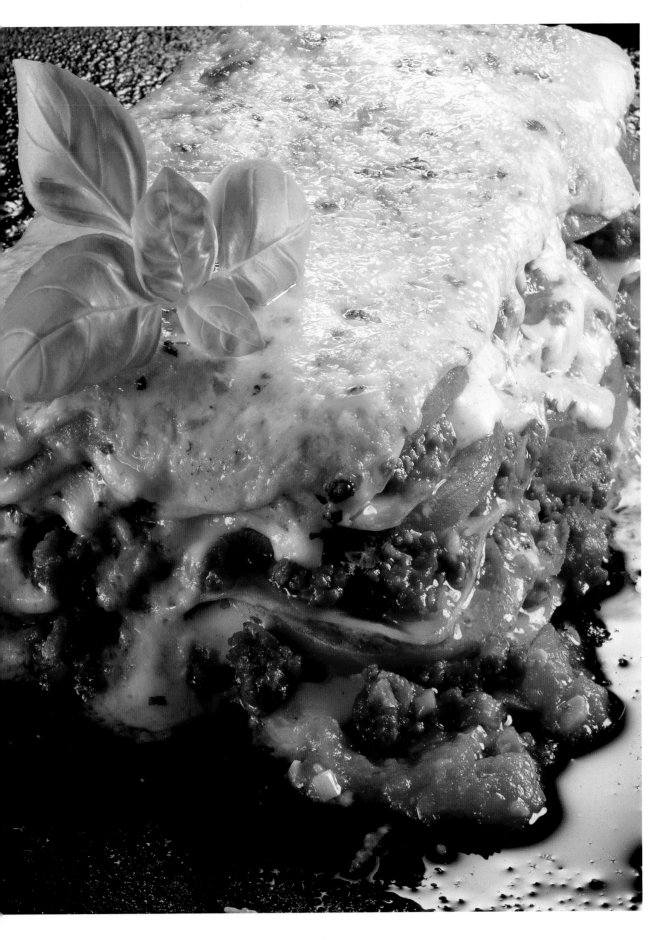

Method

Bring the pasta to a boil in salted water, add the oil, and cook according to the package instructions, then drain. Heat the butter, add the pasta, toss, and keep warm.

For the shellfish cooking liquid, peel the onion and garlic and mince them. Heat the oil and sauté the onion for 5 minutes, add the garlic and cook for 1 minute. Add the wine and bay leaf. Season with salt and pepper.

Add the mussels and cook for 5 minutes, or until they open, stirring frequently.

Dip tomatoes in boiling water for a few seconds, then plunge into cold water, remove skins and cores, cut in half, and dice.

Drain the bottled or canned mussels, defrost the shrimp. Add the tomatoes, clams, shrimp, mussels, and capers to the cooking liquid. Stir gently, bring to the boil. and cook on low heat for 2 minutes.

Add pasta and parsley, toss lightly, and serve immediately.

Ingredients

14 oz tagliatelle

1 tbsp vegetable oil

2-3 tbsp butter

For the shellfish cooking liquid

1 onion, 1 garlic clove

1 tbsp vegetable oil

½ cup white wine

1 bayleaf

salt, freshly ground pepper

12 oz fresh or frozen clams

about 2 cups tomatoes

about 1 cup mussels, fresh or canned

about ⅔ cup fresh or frozen shrimp

1 tbsp capers

chopped parsley

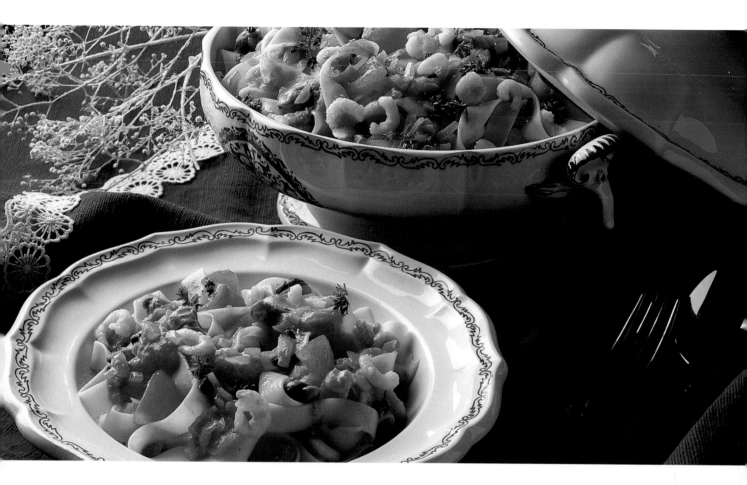

Tagliatelle with Shellfish

Method

Wash the basil leaves and pat dry. Peel the garlic. Combine the cheese, oil, pine nuts, basil, and garlic, and beat with an electric mixer. Transfer this purée to a saucepan and stir well.

Serve with soups, stews, cooked beef, and pasta. In Italy, pesto and fresh bread are eaten as an appetizer. Instead of using 2 kinds of cheese, the amount of Parmesan can be doubled.

Pesto

Ingredients

⅔ cup fresh basil leaves

6 garlic cloves

3 tbsp grated Pecorino cheese

3 tbsp grated Parmesan cheese

1 scant cup olive oil

⅓ cup pine nuts (pignolas)

Tip

Freeze the pesto in portions.
The pesto will keep for six months
in a freezer.

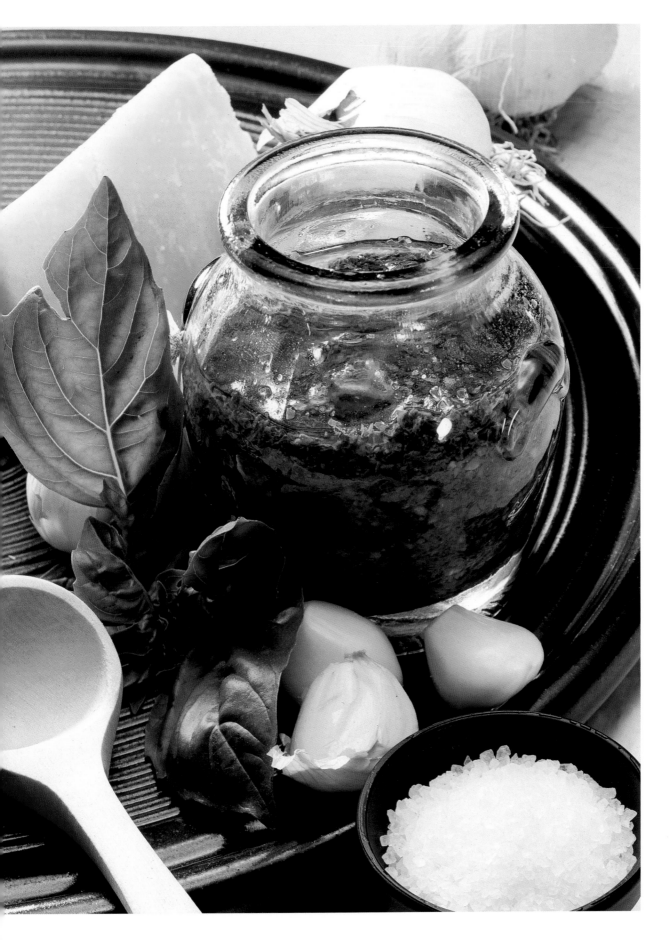

Method

Skin and remove the cores from the tomatoes and chop into large pieces.

Peel and chop the garlic.

Heat the oil in a skillet, add the tomato and garlic, and stir until the mixture is reduced to a thick sauce. Season with salt, pepper, and sugar.

Ingredients

5 cups tomatoes

3 garlic cloves

4 tbsp olive

salt

freshly ground pepper

a pinch of sugar

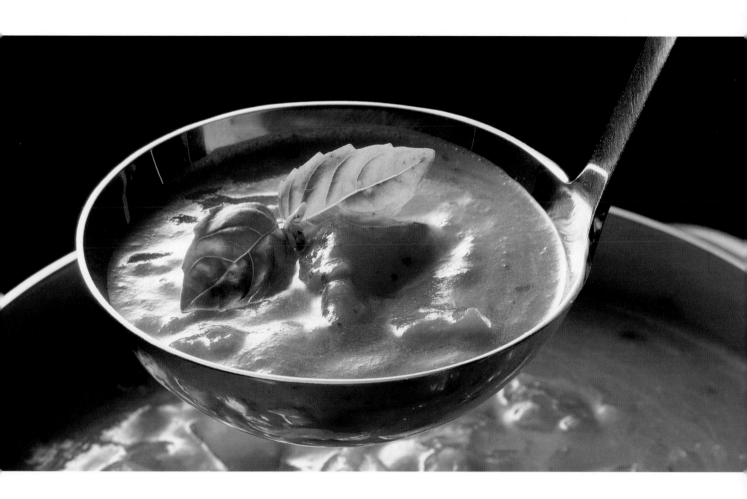

Fresh Tomato Sauce

Method

Wash the fresh spinach, and cook for few minutes in a saucepan without added water until it wilts. Heat frozen spinach without thawing, stirring until it boils. Drain in sieve and leave to cool. Squeeze out excess water. Chop and heat again with 1 tablespoon butter and salt. **Leave** to cool. Stir in the eggs, 3 tablespoons Parmesan cheese and pinch grated nutmeg.

Heat the meat broth, add the spinach, cover, and remove from heat. Let stand for few minutes, so the eggs can bind the soup.

Fry the bread in the remaining butter until golden brown. Pour the soup into warmed soup bowls and serve with remaining cheese.

Spinach Soup

Ingredients

6 cups chopped spinach leaves

or 2 cups frozen spinach

4 tbsp butter

2 medium eggs

salt, grated nutmeg

⅔ cup Parmesan cheese

4 cups meat broth

3 slices Italian-style bread

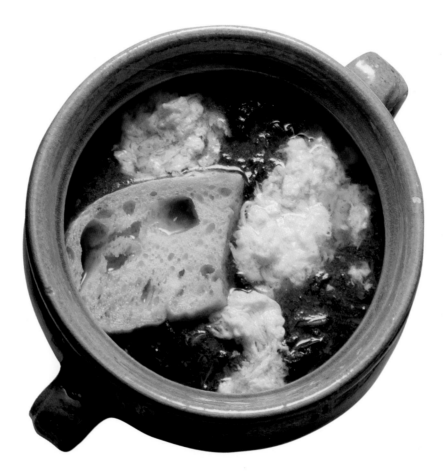

Method

Slice the eggplant lengthwise into 1⁄2-inch thick slices.

Sprinkle with salt. Stack several slices on top of each other, cover with a kitchen towel, and repeat. Cover with a chopping board and weigh it down with heavy cans of food or other weights.

After 2 hours, press down again and thoroughly pat each slice dry.

Mix the flour, basil, and herbs. Dust the eggplant slices with this mixture, dip in the lightly beaten eggs, and fry in hot oil until golden brown.

Drain on absorbent kitchen paper and serve hot.

Ingredients

2 large eggplant

salt

around 3 tbsp all-purpose flour

1 tsp dried basil

freshly ground pepper

pinch of nutmeg

2 medium eggs

oil for frying

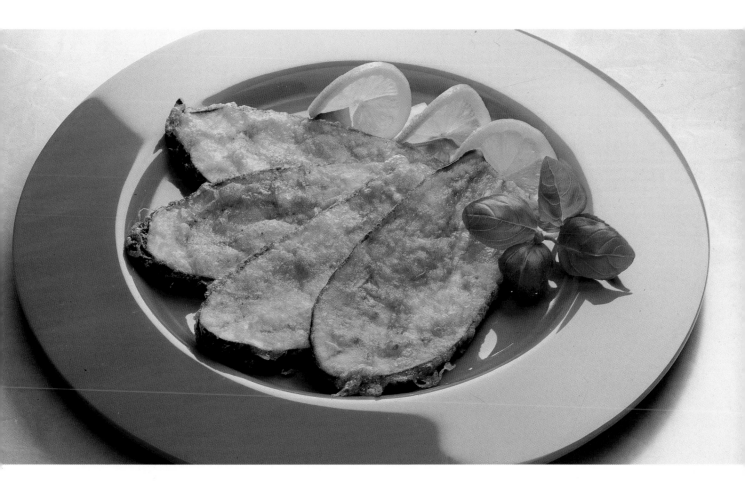

Fried Eggplant

Tip

Fried eggplant is often served in the countries

of the Mediterranean basin as an appetizer with

a yogurt sauce.

tuscany

Method

Break the pasta into finger-length pieces and cook in boiling salted water to which the oil has been added. Cook the pasta until *al dente* according to the instructions on package. Drain in a colander Rinse fish fillets under cold running water, pat dry, drizzle with lemon juice, pat dry again and sprinkle with salt. Bring the broth to the boil with wine, add the fish and cook for 6 minutes.

Place the pasta in a buttered deep ovenproof dish and arrange the fish on top. Grate the cheese and sprinkle a third of it over the fish. Wash the leeks and fennel and slice them into rings. Skin and core the tomatoes and quarter them. Melt the butter, and sauté the leeks and fennel for 10 minutes. Add the tomato and briefly heat through. Add the heavy cream. Season the vegetables with salt and pepper and arrange them over the fish. Sprinkle with remaining cheese and dot with butter if desired. Place in oven.

Oven

Conventional oven: 400°F (preheated)

Fan-assisted oven: ca. 180 °F (preheated)

Gas oven: Mark 3-4 (preheated).

Baking time: around 30 minutes

Sardinian Zitti with Fish

Ingredients

8 oz macaroni, 1 tbsp vegetable oil

14 oz fish fillet, e.g. cod or red snapper

lemon juice, salt, ½ cup fish broth

½ cup dry white wine

7 oz Gouda cheese

1 leek, 2 fennel bulbs, 5 tomatoes

3 tbsp butter, 1 scant cup heavy cream

freshly ground pepper, 4 tsp butter flakes

Remarks

Zitti are a special type of Italian pasta, not as long as spaghetti, but thicker and hollow. If you cannot find zitti, use ridged penne or rigatoni instead.

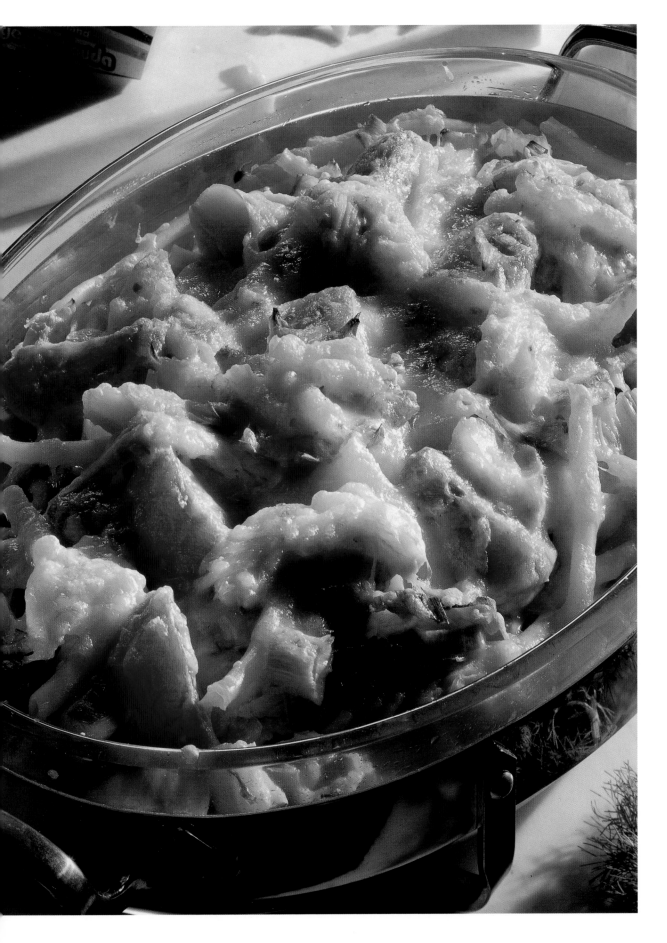

Method

Rinse the chicken breasts under cold running water, pat dry, and rub with salt and pepper. Wrap each chicken breast piece in a thin slice of ham and secure with a cocktail stick.

Heat the oil in a skillet and gently sear chicken breast on both sides for 15 minutes. Remove from the skillet and keep warm.

Deglaze the pan with Marsala wine, mix with crème fraîche and boil briefly. Season the meat with salt, remove the cocktail sticks, and transfer the chicken to the Marsala sauce. **Reheat** for 2 minutes before serving.

Ingredients

4 small chicken breast fillets (4 oz each)

freshly ground pepper

chopped sage

4 thin slices raw ham

2 tbsp clarified butter

3-4 tbsp marsala wine

⅔ cup crème fraîche

salt

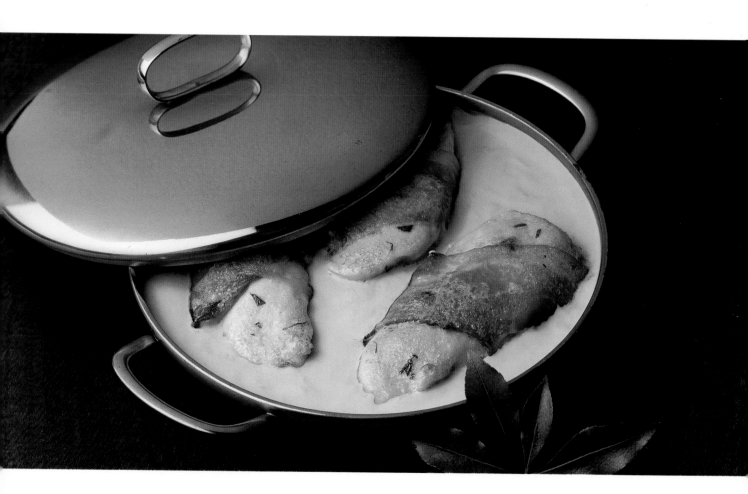

Chicken Breast in Marsala Sauce

Serving suggestion

Risotto, mixed leaf salad

Tip

French bread and green salad go well with this rich

chicken dish

tuscany

Method

Cut bell peppers in half lengthwise and cut or pull out the stems and seeds, along with the white ribs. Place them on a dry cookie sheet in the oven.

Oven

Conventional oven: 450 °F (preheated)

Fan-assisted oven: 425 °F (preheated)

Gas oven: Mark 5 (preheated)

Roast the peppers until the skins blister and begin to blacken. Cover briefly with a damp kitchen towel.

Peel off the skins and slice the flesh into strips. Wash the zucchini, trim the ends, and cut into slices. Peel and chop the garlic. Wash the basil, pat it dry, pick off the leaves, and chop them. Slice the mozzarella. Lightly grease a jelly-roll pan, add bell pepper, mozzarella, zucchini, and black olives. Season with salt and pepper. Mix the oil with garlic and basil and pour the mixture over the vegetables. Place in the oven.

Italian Vegetable Bake

Ingredients

2 yellow bell peppers, 2 red bell peppers

4 medium zucchini, 1 garlic clove

1 bunch basil, 7 oz mozzarella

4 tbsp black olives, pitted

salt, freshly ground pepper

6 tbsp soya oil

Oven

Conventional oven: 400°F (preheated)

Fan-assisted oven: 375°F (preheated)

Gas oven: Mark 3-4 (preheated)

Baking time: 25-30 minutes

Tip

Serve with French bread and chianti.

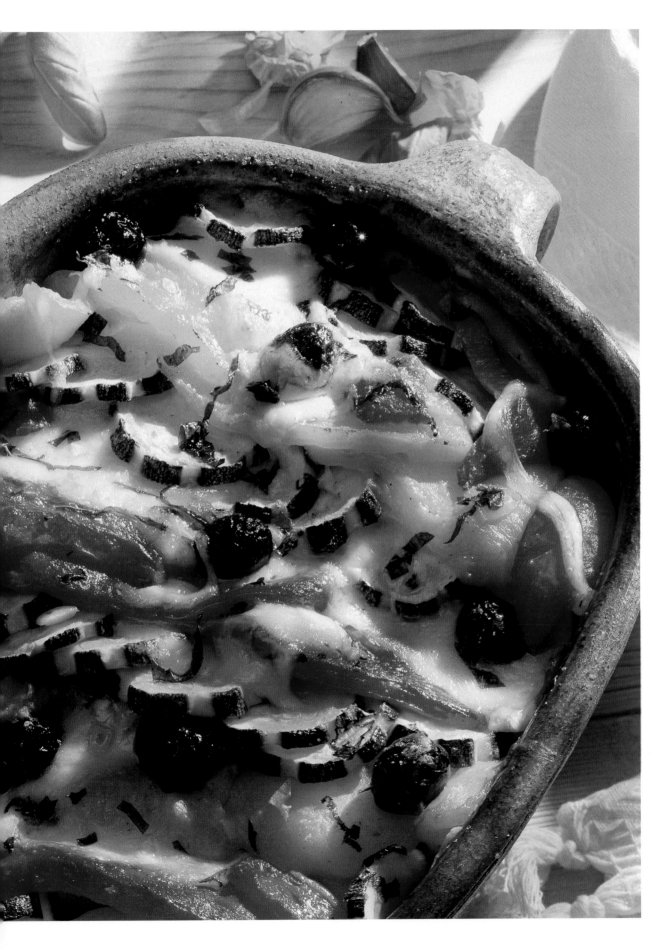

23

Method

Sift the flour into large bowl and mix with the salt. Make well in the center, place crumbled fresh yeast, water, and oil in the well. Dissolve the yeast, add to the well, and cover with some of the flour. Leave in a warm place for 10 minutes. Knead the dough by hand from the center outward until smooth and elastic. **Shape** dough into a ball, cut a cross in it, dust with more flour, cover with a damp kitchen towel, and leave to rise in a warm place for 1 hour. Rinse the fish, pat dry, and cut into 1/2-inch chunks. Cut the tomatoes in half, remove the cores, and chop them. Wash the celery, remove the coarse fibers, and chop it. Peel and mince the shallots. **Heat** the oil and sauté the shallots. Add the celery and sauté. Add the fish and tomato, and season with salt and pepper. Peel and mince the garlic. Wash and chop the basil. Add the garlic and basil to the fish mixture. Roll out the dough and place in a 10-inch pizza pan or arrange on a cookie sheet. Brush with little oil and cover with the topping. **Drain** the mozzarella, grate it, and sprinkle it over the pizza. Place in the oven.

Pizza with Monkfish and Celery

Ingredients

For the pizza dough

4 cups all-purpose flour, salt

4 tsp fresh yeast, ½ cup warm water

½ tsp olive oil

For the filling

14 oz monkfish filet, 2 beefsteak tomatoes

8 large celery sticks

4 shallots

4 tbsp olive oil, salt

freshly ground pepper

1 garlic clove

5 basil leaves, olive oil

14 oz mozzarella

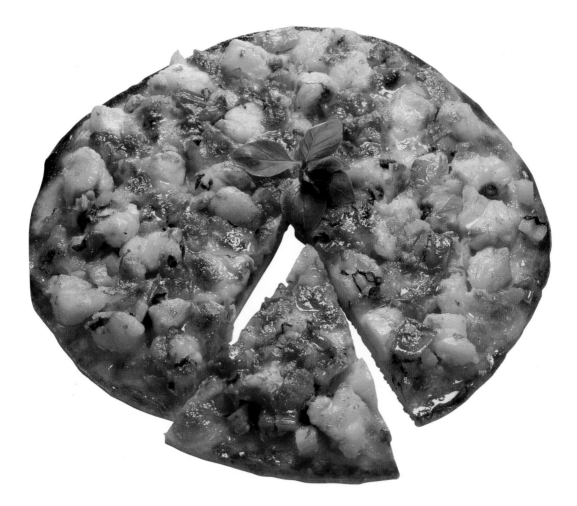

Oven

Conventional oven: 400ºF (preheated)

Fan-assisted oven: 375ºF (preheated)

Gas oven: Mark 3-4 (preheated)

Baking time: around 25 minutes

tuscany

Method

Rinse the eggplant, cut it into 1-inch slices, and dice it. Soak it in salted water for 10 minutes and pat dry. Wash, dry, and mince the parsley.

Heat the oil in a skillet and sauté the eggplant until golden brown, turning occasionally. Add the sieved tomatoes.

Peel and chop the garlic and add to the mixture. Season with salt, pepper, and oregano. Bring the mixture briefly to the boil, then remove from the heat and cool to room temperature. Sprinkle with the parsley before serving.

Ingredients

3 large eggplant

salt

vegetable oil

½ cup sieved, canned tomatoes

2 garlic cloves

freshly ground pepper

½ tsp dried oregano

½ bunch flatleaved parsley

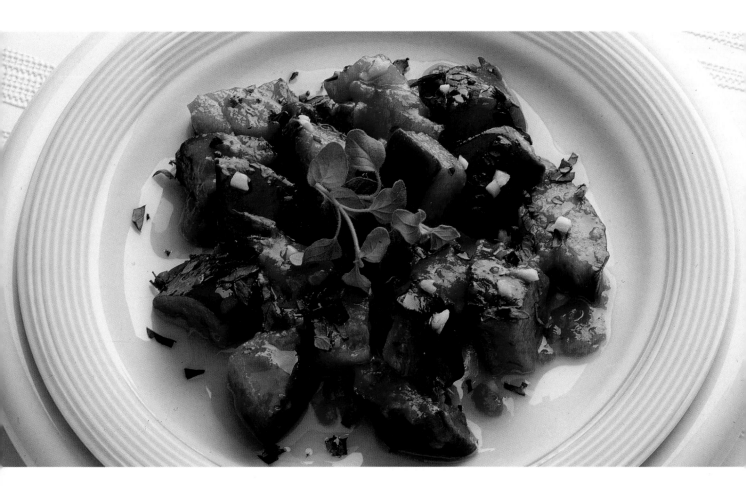

Marinated Eggplant

27

Method

Peel and mince the onions and garlic. Heat the oil and sauté them.

Add the ground beef and brown for 5 minutes. Break up the meat into smaller pieces with a fork. Season with salt, pepper, and paprika.

Add the canned tomatoes and their liquid, and break up any lumps of meat with a spoon. **Add** the tomato paste and red wine or water, stir, and bring to the boil. Cook for 10 minutes, then add the thyme and basil.

Add a little oil to boiling salted water. Cook the pasta until al dente according to instructions on the package. Drain it in a colander.

Serve with Parmesan cheese if desired.

Spaghetti Bolognese

Ingredients

For the sauce

2 onions

1-2 garlic cloves

2 tbsp olive oil

8 oz ground beef and pork (half of each)

salt, freshly ground pepper

sweet paprika

14 oz canned tomatoes

5 tbsp tomato paste

½ cup red wine or water

1 tsp dried thyme

1 tsp chopped fresh basil

For the spaghetti

14 oz spaghetti

1 tbsp vegetable oil

grated Parmesan cheese

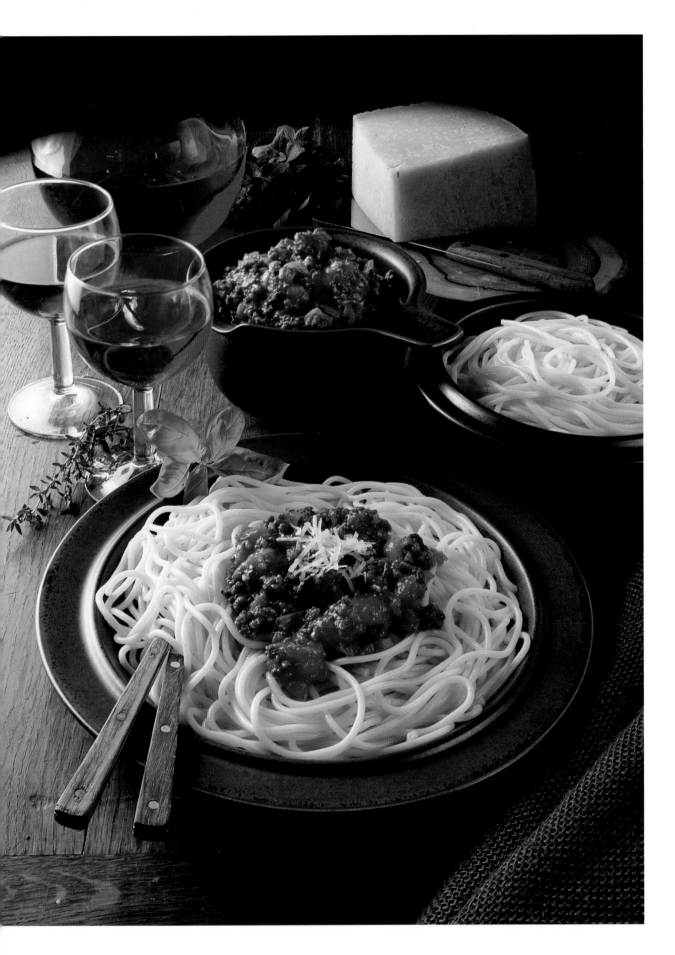

Method

Chill the melons for a few hours, cut them in half, remove the seeds, and cut each half into 6 slices.

Place a slice of ham on each slice of melon and sprinkle with freshly ground black pepper.

Ingredients

2 ripe honeydew or crenshaw melons

12 thin slices Parma ham

freshly ground black pepper

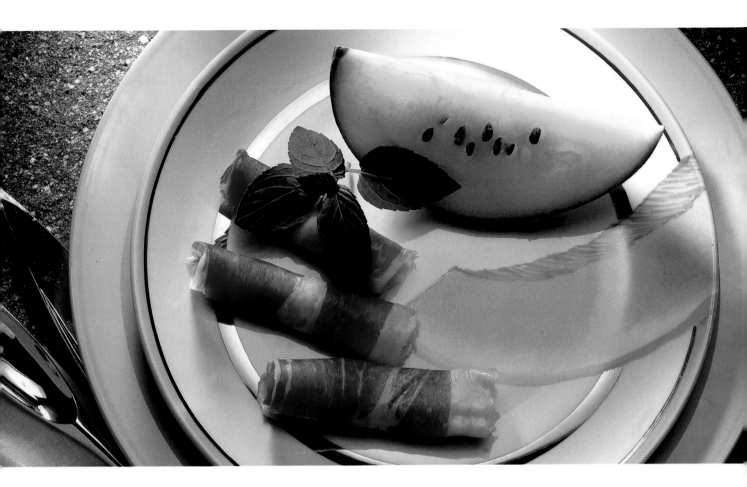

Melon with Parma Ham

Tip

Serve melon and parma ham as an appetizer

or light evening meal.

tuscany

Method

Wash, pat dry, and chop the basil and grind with the parsley, garlic, and salt in a mortar with a pestle.

Add the Parmesan cheese and grated goat's cheese. Mix well. Add 1 tablespoon oil and stir until creamy or combine all ingredients with an electric mixer.

Cook pasta in salted water until al dente according to the instructions on the package. Drain in sieve and place in a pre-heated bowl.

Toss the pasta and sauce and serve immediately.

Ingredients

For the sauce

1 bunch basil leaves

3-4 tbsp minced parsley

5 garlic cloves, peeled

1 tsp salt

4 tbsp grated Parmesan cheese

6 tbsp grated pecorino cheese

10 tbsp olive oil

14 oz spaghetti

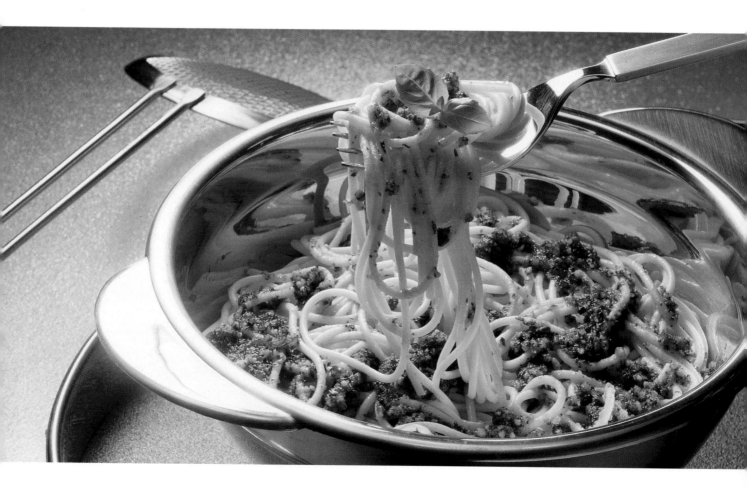

Spaghetti Genoese-style

Serving suggestion

Serve with extra grated Parmesan cheese.

Method

Heat the fish broth. Rinse the fish under cold, running water, pat dry ,and cut into small chunks. Simmer in the broth for 3 minutes, remove from broth ,and reserve.

Wash the vegetables, cut green onions into rings, and slice the fennel and bell peppers into strips. Chop the fennel fronds and set aside for garnishing.

Melt the butter, sauté the vegetables, and dust with flour. Add white wine, vermouth and broth, and reduce. Cook for 10 minutes, season with salt, pepper, and lemon juice. Add the heavy cream and crème fraîche.

Heat the fish, mussels, and shrimp in the soup, sprinkle with fennel fronds and serve.

Fish Soup with Fennel

Ingredients

4 cups fish broth or vegetable broth

7 oz salmon fillet, 7 oz red snapper fillet

2 green onions (scallions), 2 fennel bulbs

2 red bell peppers

2 tbsp butter

2 tbsp all-purpose flour

1 scant cup dry white wine

1 scant cup dry white vermouth

salt, freshly ground pepper

lemon juice, 1 cup heavy cream

⅔ cup crème fraîche

2 cups canned, shelled mussels

1 cup cooked, shelled shrimp

Tip

Fish soup can be made with a variety of freshwater and
saltwater lean fish. Recommended varieties include cod,
scrod, porgy, catfish, red snapper, redfish, weakfish, sole,
and sand dabs.

Method

Rinse the meat under cold running water and pat dry. Carefully rinse the sage and pat dry. **Place** one leaf of sage on each piece of meat. Top with folded slices of ham and secure with a cocktail stick. Season with salt and pepper, and dust with flour. **Heat** the oil and sear the meat on both sides for 2-3 minutes. Remove from the pan and keep warm. Pour the broth and vermouth into the pan and deglaze it. Season again if desired.

Veal Schnitzel with Ham and Sage

Ingredients

8 veal schnitzel slices (about 3 oz each)

8 sage leaves

8 slices Parma ham

salt

freshly ground pepper

1-2 tbsp all-purpose flour

3 tbsp olive oil

1 cup veal consommé

2 tbsp dry vermouth

Additionally

cocktail sticks

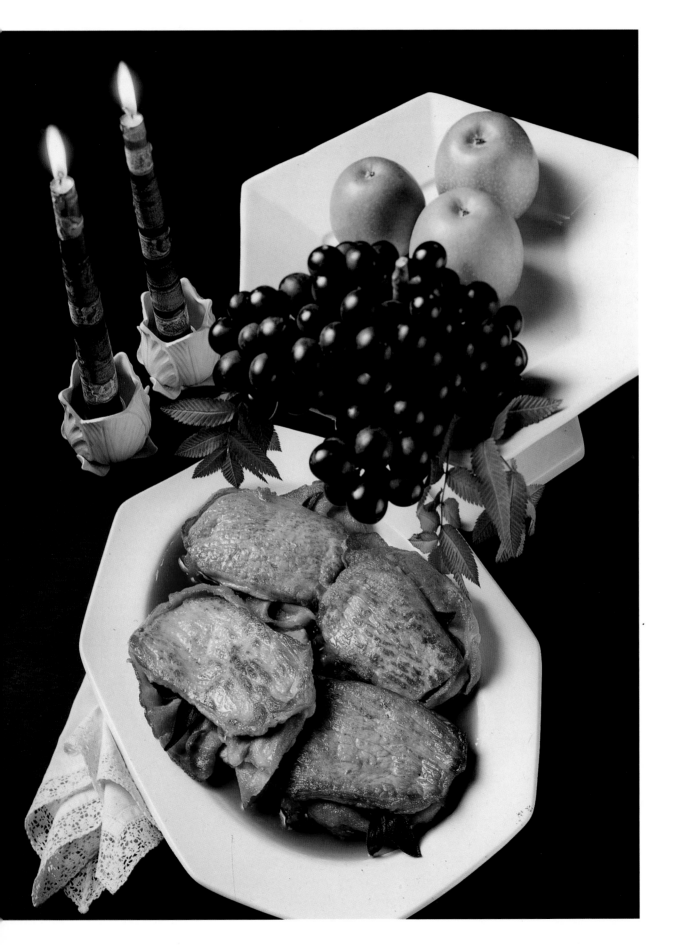

Method

Rinse lamb under cold running water, pat dry. Make small slits
in the flesh, and insert garlic slivers using a sharp knife tip. Heat the oil
and sear the meat on both sides.

Purée the tomatoes and season with rosemary, salt and pepper. Bring
to a boil briefly. Place tomato mixture in casserole, add the lamb and place
in the oven. Add the peas shortly before the meat is cooked and simmer
for a maximum of 10 minutes. Remove the meat, bone it, and cut into
slices.

Ingredients

1 leg of lamb (3lb 5 oz)

12 garlic cloves, peeled

6 tbsp olive oil

14oz can of tomatoes with juice

pinch of dried rosemary

salt, freshly ground pepper

2 cups fresh or frozen green peas

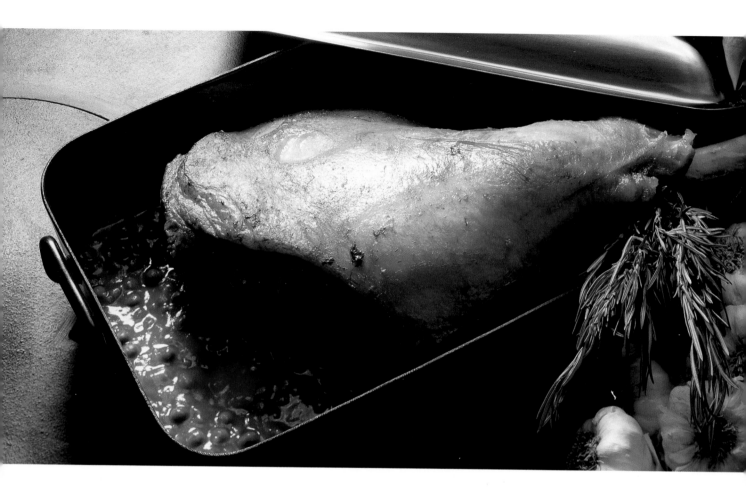

Tuscan Leg of Lamb

Oven

Conventional oven: 375°F (preheated)

Fan-assisted oven: 350°F (not preheated)

Gas oven: Mark 2-3 (not preheated)

Roasting time: about 1½ hours

tuscany

Method

Wash oranges under hot running water, dry. Peel 3 oranges and set aside.
Thinly peel the lemon, and slice the rind into matchstick strips. Squeeze the oranges
and lemon. Pour the juice into a saucepan, add the sugar and the grated orange
rind. Reduce the liquid to a syrupy sauce over medium heat.

Peel the figs and cut them in half. Pour the hot orange sauce over the figs
and sprinkle with the matchstick strips of lemon rind. Cover with plastic wrap
and refrigerate overnight.

Whip the cream with vanilla until semi-stiff. Add sugar to taste. Spoon
the whipped cream over the figs and serve ice-cold.

Ingredients

4 untreated orange

1 lemon

1 cup sugar

12 fresh black figs

1 scant cup whipping cream

1 package vanilla sugar

extra sugar to taste

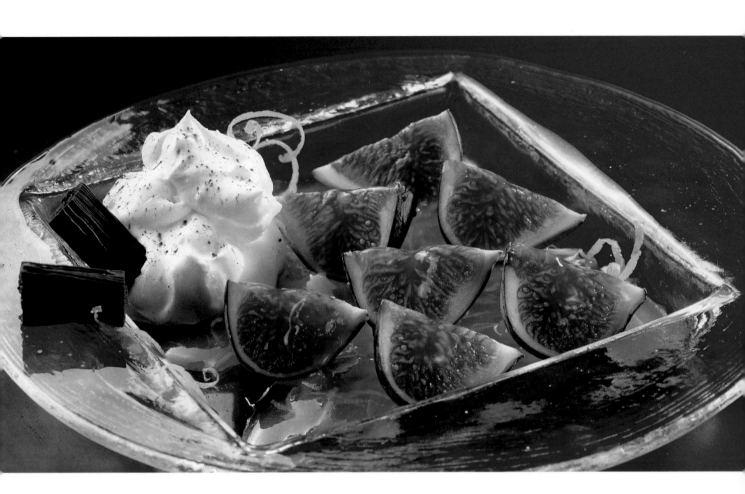

Figs in Orange Sauce

Method

Bring the pasta to the boil in boiling salted water. Add the oil, and cook according to the package instructions. Drain well.

Heat the butter, add the pasta, and toss. Place the pasta in a bowl and keep it warm.

Peel and chop the garlic. Clean the mushrooms, rinse if necessary, and slice. Wash, dry, and mince the parsley. Drain the mussels, reserving the liquid.

Heat the butter or margarine in a saucepan and sauté the garlic. Add the mushrooms and parsley, and sauté for 5 minutes. Add 1 tablespoon of the mussel liquid, cover the pot, and simmer for 10 minutes. Add the mussels and heat through. Season with salt, pepper, and onion powder. Spoon the mixture over the pasta and serve immediately.

Tagliatelle with Mussels

Ingredients

8 oz tagliatelle (fettuccini)

1 tbsp vegetable oil

2 tbsp butter

1-2 garlic cloves

2 cups mushrooms

1 bunch parsley

4 cups canned mussels (without shell)

4 tbsp butter or margarine

salt

pepper

onion powder

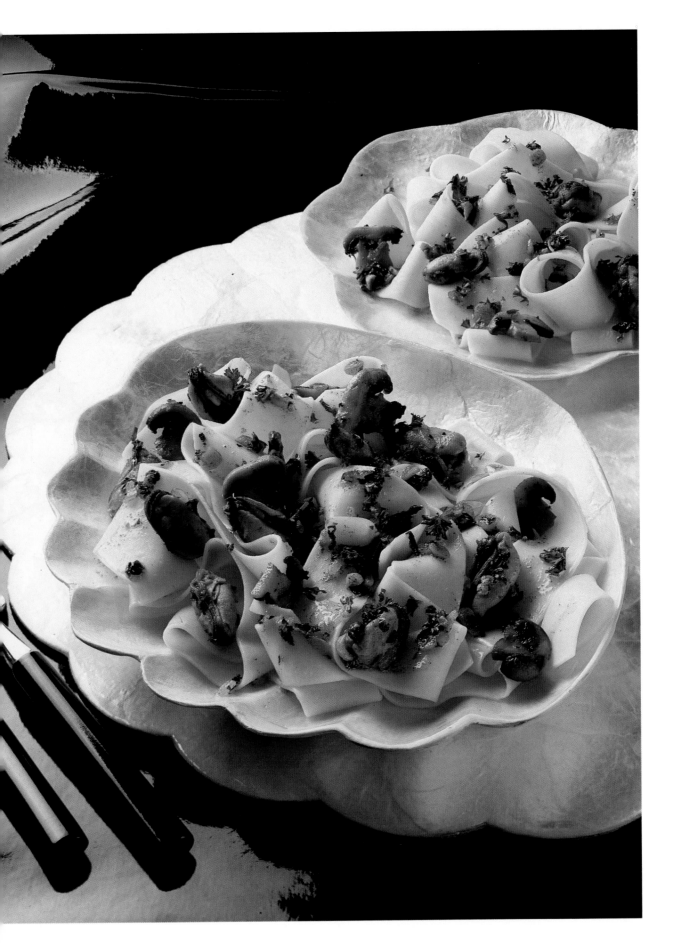

tuscany

43

Method

Sift flour into a mixing bowl. Add the sugar, lemon rind, and butter. Fit the mixer with dough hooks and beat on a low speed until blended. Beat on high speed until smooth.

Knead by hand until smooth and elastic. Leave to rest in a place. Roll out the dough in a rectangle 1/8 inch thick, and cut rounds from it with a cookie cutter or glass.

Place the rounds on a greased cookie sheet lined with nonstick baking paper. Beat the marzipan in a mixing bowl. Gradually add sifted powdered sugar, egg yolks, and lemon juice and beat until creamy. Spoon the mixture into piping bag with star nozzle and pipe whorls onto half the rounds of dough. Place in oven.

Remove from the oven when baked and leave to cool. Beat marzipan topping mixture with an electric mixer, add the rum or arrack, and apricot jam. Spread the mixture on those cookies that are not topped with the marzipan mixture. Place them on top of marzipan-covered cookies. Quarter the cherries and garnish each cookie with piece of cherry. Strain the apricot jam, mix with water, and boil briefly. Spread it on the cookies.

Milanese Marzipan Cookies

Ingredients

For the cookie dough

2 scant cups all-purpose flour, 5 tbsp sugar

½ untreated lemon, rind grated

½ cup softened butter

For the filling

4 oz baking marzipan

2 tbsp sifted powdered sugar

1 medium egg yolk, 1 tbsp lemon juice

For the filling

3 oz baking marzipan

1-2 tbsp rum or arack

1 tbsp apricot jam

3-4 candied cherries

For the apricot topping

1½ tbsp apricot jam, 2 tsp water

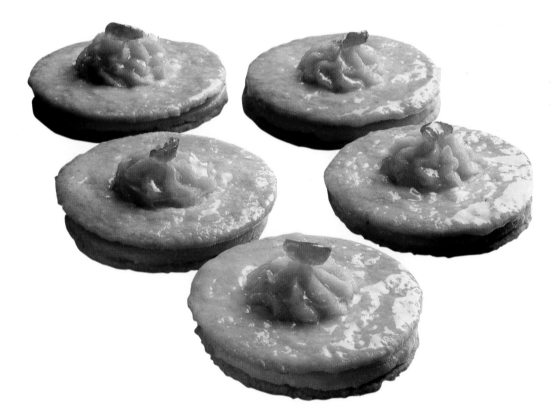

Oven

Conventional oven: 375-400ºF (preheated)

Fan-assisted oven: 350-375ºF (preheated)

Gas oven: Mark 3 (preheated)

Baking time: around 15 minutes

Method

Dissolve the fresh yeast in water, add the flour, water, and oil and knead with the dough hook of an electric mixer for 5 minutes, or until smooth and elastic. Wash and chop the parsley and sorrel. Peel and chop the garlic. Knead the sorrel, parsley, and garlic into the dough. Cover and leave to rise in a warm place. Divide into 12 balls, flatten them, and roll out thinly on a floured board.

Wash carrots, peel them, and cut into 1/4-inch pieces. Heat the oil and sauté the carrots until half-cooked, about 5 minutes. Season with a pinch of salt. Wash the tomatoes, remove the cores, and cut into slices 1/2-inch thick. Wash the zucchini, trim the ends, and cut into 1/4-inch thick slices. Drain the mozzarella and shred it.

Cover 4 pizzas with zucchini, 4 with carrots, and 4 with tomatoes. Sprinkle all of them with the mozzarella, salt, and pepper and place on a greased cookie sheet. Bake in the oven.

Drizzle with oil and sprinkle with basil when cooked. Serve hot.

Ingredients

For the yeast dough	For the topping
4 tsp fresh yeast, 2-3 tbsp warm water	6 carrots, 1 tbsp corn oil
2⅓ cups whole-wheat flour	salt, 3 cups small, firm tomatoes
1 cup warm water, 1 tbsp corn oil	6 small zucchini, 11 oz mozzarella
½ tsp salt, 1 bunch parsley	pepper, 4 tbsp corn oil
1 bunch sorrel, 2 garlic cloves	1 tbsp fresh chopped basil

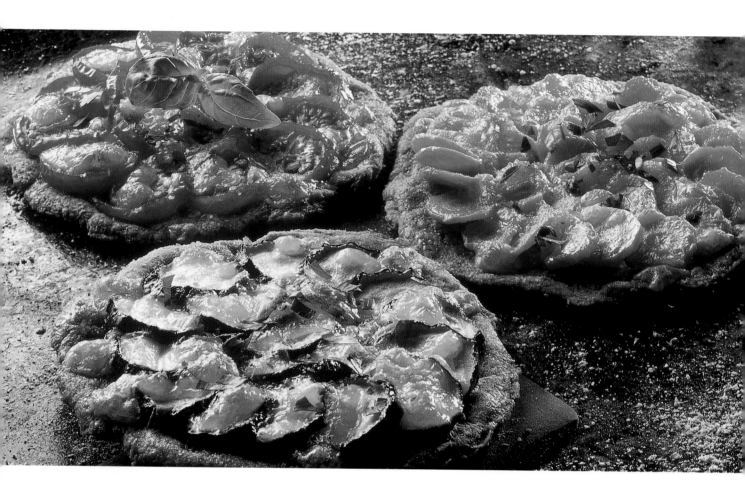

Mini Pizzas

Oven

Conventional oven: 375-400°F (preheated)

Fan-assisted oven: 350-375°F (preheated)

Gas oven: Mark 3 (preheated)

Baking time: 25-30 minutes

Method

Using a hand mixer fitted with beaters, beat the butter on highest speed for 30 seconds until creamy. Gradually add the sugar, vanilla sugar, salt, and grated lemon rind. Mix well and beat in the eggs one by one, at 30 second intervals, beating well after each addition.

Sift the flour with the baking powder. Beat half into the butter mixture, and mix well. Knead in the rest of the butter mixture by hand. Roll the dough into a ball, wrap it in plastic wrap, and leave in a cool place overnight.

Roll out the dough into a rectangle 1/4 inch thick. Press a pattern into dough with a grater, then cut out shapes with cookie cutter. Arrange the cookies on a cookie sheet lined with nonstick baking paper, and place in the oven.

Immediately after baking, spread the butter on the cookies. Combine the sugar with the vanilla sugar and sprinkle the mixture over the cookies.

Oven

Conventional oven: 375-400°F (preheated)

Fan-assisted oven: 160-180 °F (preheated)

Gas oven: Mark 3 (preheated)

Baking time: around 12 minutes

Milanese Cookies

Ingredients

For the dough

1¾ cups softened butter

1 cup sugar

2 tsp vanilla sugar, salt

1 untreated lemon, rind grated

3 small eggs

4 cups all-purpose flour

2 level tsp baking powder

For sprinkling

about 8 tbsp melted butter

4 tbsp sugar

2 tsp vanilla sugar

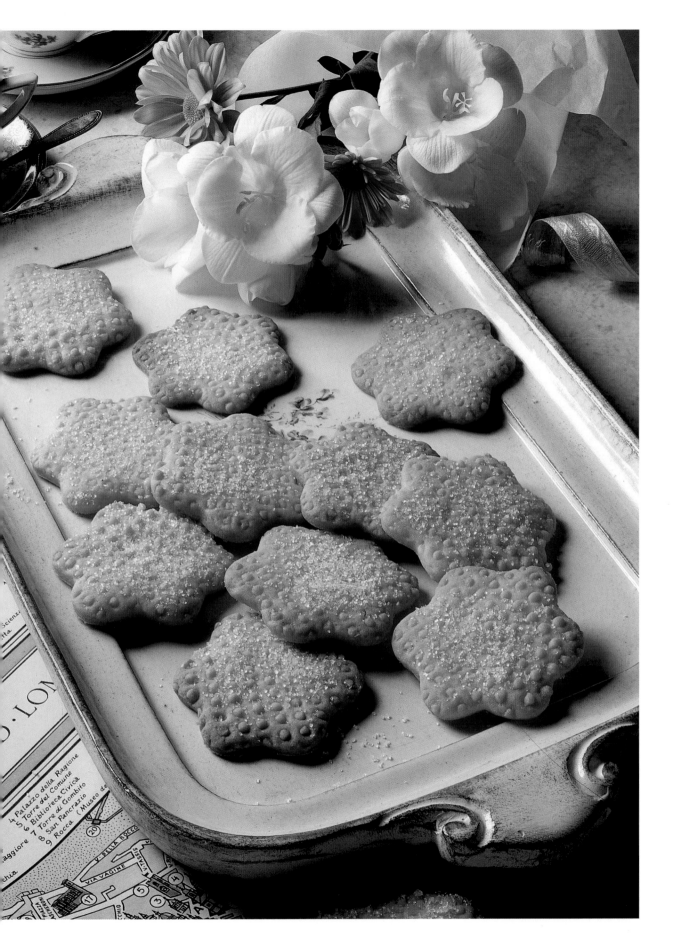

Method

Wash the lettuce and arrange it on a plate. Drain the tuna, break into chunks with a fork, and arrange it on the lettuce.

Peel the onion and slice it into rings. Toss it on the salad and top with capers.

Mix the oil, lemon juice, pepper, and salt and drizzle this over salad. Refrigerate for a few hours in a bowl covered with plastic wrap, for the flavors to mingle.

Ingredients

lettuce leaves

2 cups canned tuna in water

1 red onion

2 tbsp capers

½ cup olive oil

1 lemon, juice squeezed

freshly ground pepper

salt

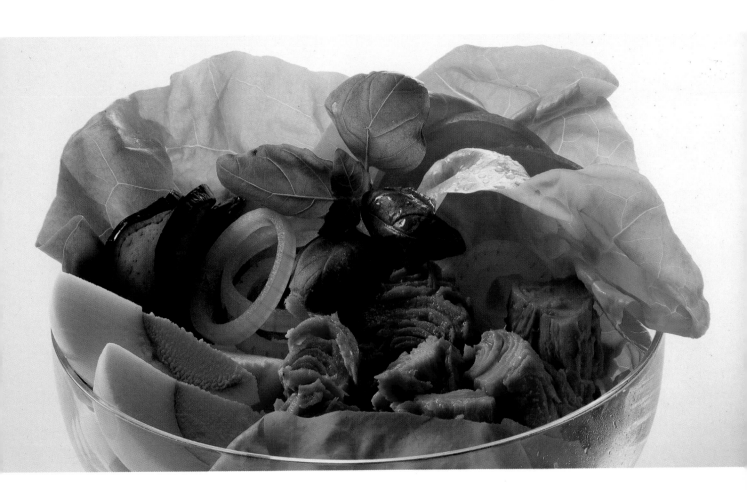

Tuna Salad

tuscany

51

Method

Sift the flour into a large bowl. Add the rest of the dough ingredients and mix thoroughly with a hand mixer at low speed until blended, then beat at highest speed. Knead by hand until smooth and elastic and let rest in refrigerator for 30 minutes.

Rinse the meat under cold running water, pat dry, and dice. Mix the soy sauce with the sugar and pepper and place the meat in the marinade.

Drain and quarter the pineapple. Wash the tomatoes, remove the cores, and cut into 8 wedges.

Wash the chicory, cut out the bottom, and slice into thin rings.

Mix tomato paste with water.

Briefly knead the dough, then roll it out, and transfer it to a 12-inch pizza pan or shape it on a baking sheet. Press out the dough from the center to the edge so the edge is thicker than center and slightly raised to prevent the filling escaping. Cover with tomato mixture.

Wash the green onions, cut into rings, and sprinkle them over tomato mixture. Cover with the meat, pineapple, and wedges of tomato. Sprinkle with the chicory. Grate the cheese and sprinkle it over the pizza. Place the pizza in the oven.

Ingredients

For the pizza dough

2 cups all-purpose flour, 1 medium egg

½ tsp salt, 5 tbsp buttermilk

⅓ cup cold butter

For the topping

7 oz lean, boneless pork, 3 tbsp soy sauce

½ tsp brown sugar

freshly ground pepper

5 slices canned pineapple

4 small tomatoes

1 head chicory (Belgian endive or witloof)

2 tbsp tomato paste

2 green onions (scallions)

8 thin slices cheese

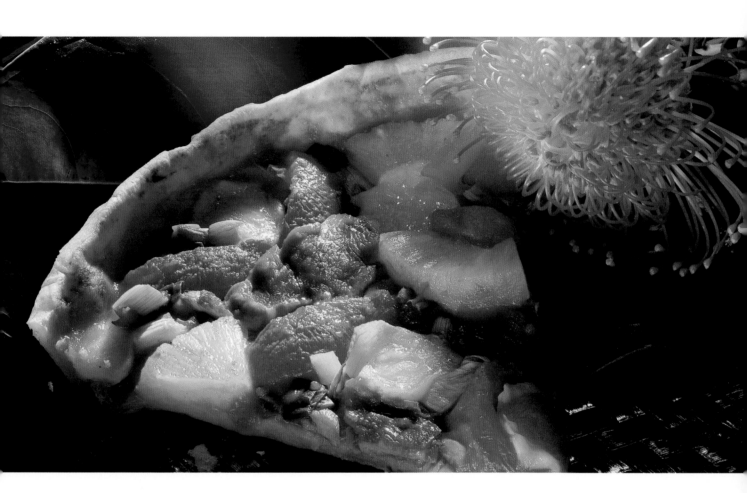

Exotic Pizza

Oven

Conventional oven: 400°F (preheated)

Fan-assisted oven: 375°F (preheated)

Gas oven: Mark 3-4 (preheated)

Baking time: around 30 minutes

tuscany

53

Method

Remove the fat and skin from the pork, rinse under cold running water, pat dry and cut into 10 1-inch slices. Season with pepper.

Rinse the sage, pat it dry, and place 2 leaves on each piece of meat.

Cut the slices of pancetta in half and place 1 piece on each medallion. Wrap each in a slice of bacon. Arrange on skewers, alternating meat and olives.

Brush with oil, place over a hot grill or under a preheated broiler. Grill or broil for 15 minutes, turning occasionally.

Florentine Pork Medallions

Ingredients

2 small pork fillets (10 oz each)

freshly ground pepper

20 sage leaves

5 thin slices pancetta

10 thin slices lean smoked bacon

20 stuffed olives

3 tbsp olive oil

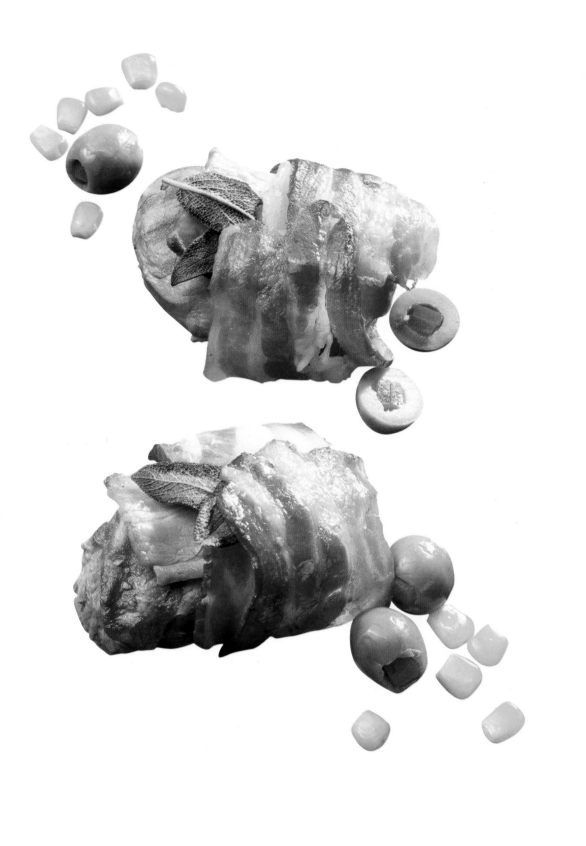

Method

Slice the olives, chop the anchovies and onion, and slice the cheese thinly. Mix all ingredients with all but 2 tbsp of the oil and salt.

Layer the mixture with the broccoli in a casserole or Dutch oven. The top layer should be broccoli.

Drizzle with remaining oil. Add enough red wine to cover the vegetables. Cover the pot and transfer it to the oven. Cook on low heat for 1½ hours or until all wine has been absorbed.

Sicilian Broccoli

Ingredients

2 tbsp pitted black olives

8 anchovy fillets

1 small onion, peeled

2 oz mature half-fat cheese

1 cup olive oil

salt

10 cups broccoli flowerets

around 2 cups dry red wine

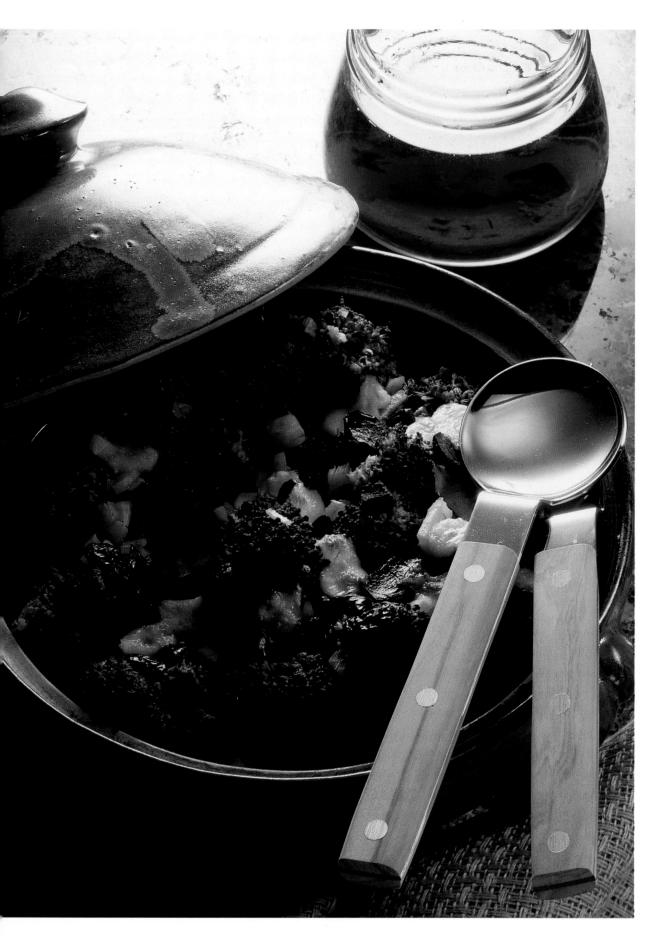

tuscany

57

Method

Mix the flours and baking powder in a large bowl. Add the curd cheese, oil, egg, oregano, salt and water. Knead using the dough hook on a hand mixer, beating on low speed until blended. Then beat on high speed for 1 minute until smooth. Do not beat for too long, or the dough will become sticky. Place the dough on a floured board and roll it into a ball. Covers with plastic wrap and leave to rest.

Cut the broccoli into flowerets, wash, and drain it. Bring the water to the boil with salt, and cook the broccoli for 4 minutes. Remove from the pan with a slotted spoon, dip briefly in cold water, and drain. Rinse the peas, trim them, and cut larger peas in half.

Cook in salted water for 2 minutes, briefly dip in cold water, and drain. Wash the green onions and slice them into rings. Wash the zucchini, pat dry, and cut into 1/4-inch slices.

Wash the parsley under cold running water and pat dry. Pick leaves off stalks. Puree the basil leaves and parsley with the sour cream and eggs. Sprinkle the dough with more flour, knead it briefly, and roll it out in a rectangle to cover a greased cookie sheet.

Spread the egg mixture over the dough. Cover each quarter of the pizza with a different kind of vegetable. Grate the mozzarella and Swiss cheese and sprinkle them over the pizza. Place in oven.

Ingredients

For the cottage cheese and oil dough

1¾ cups whole-wheat flour, 2 tbsp cornmeal, 1 tsp baking powder

⅔ cup small-curd cottage cheese, 6 tbsp olive oil, 1 medium egg

1 tsp dried oregano, 1 tsp salt, 2-3 tbsp water

For the topping

1¾ cups broccoli, salted water,

1 cup green peas, 4 green onions (scallions)

7 oz zucchini, 1 bunch flatleaved parsley, 1 small pot fresh basil

1⅓ cups sour cream, 2 medium eggs

1 cup mozzarella, 1 cup grated Swiss cheese

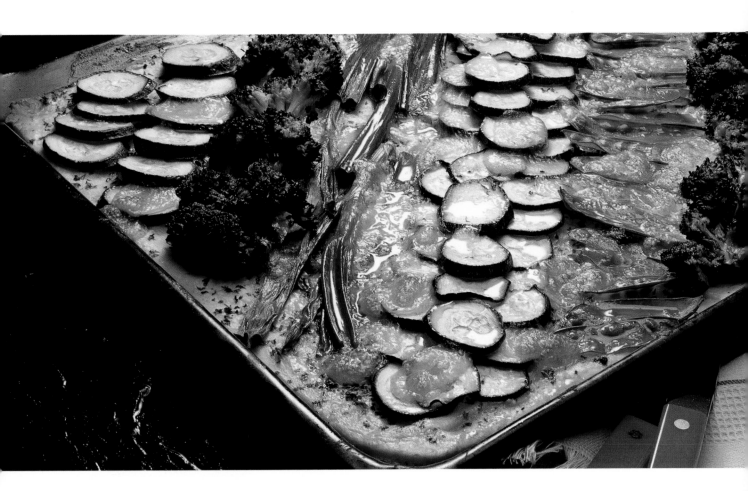

Giant Vegetable Pizza

Oven

Conventional oven: 375-400ºF (preheated)

Fan-assisted oven: 350-375ºF (preheated)

Gas oven: Mark 3 (preheated)

Baking time: around 30 minutes

Method

Remove the skin from meat, rinse and pat dry. Remove the fat and cut into 8 portions. Mix the vinegar with the water. Peel and chop the garlic. Peel the celery root, wash and grate it. Mix the garlic, celery root, herbs, and vinegar together. Add the meat, and leave for 24 hours in a cool place, turning occasionally. Remove the meat, pat it dry, and dust with flour. **Heat** the oil in a casserole or Dutch oven and sear the meat. Add a little white wine. Cover and simmer for 1 hour, basting occasionally with the cooking liquid and gradually replacing evaporated liquid with wine and broth. Remove the cooked meat and keep it warm. **Deglaze** the cooking liquid with the remaining wine. Add the tomato paste and tomato pulp, and reduce slightly. Cube the bacon, fry it in oil, and add it to the sauce. Peel and chop the garlic and add to the sauce. Season with salt and pepper and add the brandy. Pour the sauce over the meat.

Rabbit in Tomato Sauce

Ingredients

1 oven-ready rabbit (1,5 kg)

1 cup red wine vinegar

1 cup water, 1 garlic clove

¼ celery root, 1 tbsp dried thyme

2 bayleaves, salt

freshly ground pepper, 4 tsp all-purpose flour

6 tbsp clarified butter

½ cup white wine

½ cup meat broth

2 tbsp tomato paste

⅔ cup sieved tomatoes

4 slices fat bacon, 3 tbsp olive oil

1 garlic clove, 4 tbsp brandy

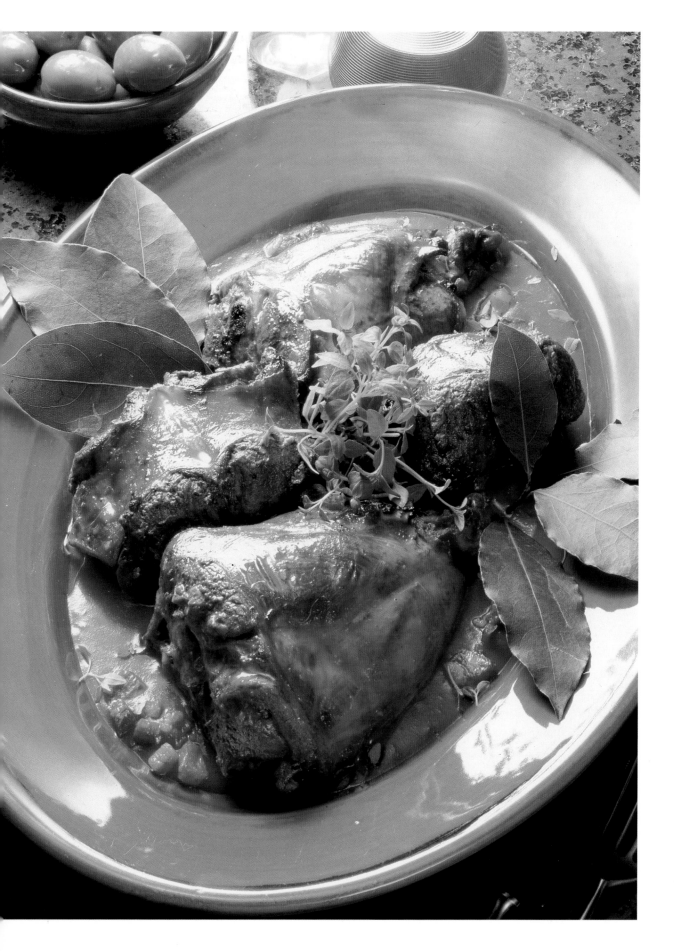

Method

Beat the butter with an electric whisk until soft. Wash the dill and chervil and pat dry.

Cut dill into very small pieces with scissors and chop the chervil.

Mix the butter with the herbs and season with lemon juice, salt, and pepper. Shape butter mixture into a roll, wrap in aluminum foil, and refrigerate.

Defrost the jumbo shrimp and rinse under cold running water. Place the shrimp into salted boiling water, with garlic, washed parsley, pepper and salt, cook for 2 minutes. Strain through a sieve, then rinse under cold running water and drain. Peel and devein the shrimp. Peel and chop garlic and mix with the oil. Briefly put tomatoes into boiling water (do not cook), plunge into cold water, remove the skins and cores and quarter them. **Drain** the olives and pat dry. Arrange alternate jumbo shrimp, tomatoes, and olives on skewers. Brush with the garlic-flavored oil and place over a hot grill or under a broiler for 3-4 minutes, turning and brushing with more oil occasionally. Sprinkle with salt and pepper when cooked and serve with slices of dill butter.

Ingredients

For the dill butter

6 tbsp butter, 2 bunches dill, 1 bunch chervil

1 tsp lemon juice, white pepper

For the kabobs

2 cups frozen jumbo shrimp, 1 garlic clove

3 sprigs parsley, ½ tsp peppercorns

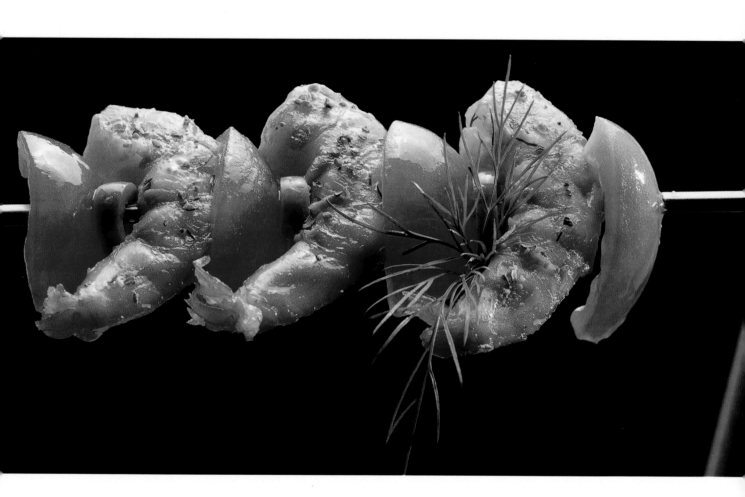

Jumbo Shrimp Kabobs with Dill Butter

4 tomatoes, ⅔ cup stuffed olives

2 garlic cloves

6 tbsp olive oil, freshly ground black pepper

Serving suggestion

Whole-wheat toast, tomato salad

Method

Rinse the meat, pat it dry, and rub it with pepper. Peel and chop the onion. Heat the oil and sear the meat on both sides. Add the onion and olives, and sauté for 5 minutes. Add the broth and simmer for 30 minutes.

Briefly place tomatoes into boiling water (do not cook them), then plunge into cold water. **Skin** and core them, cut them into 8 wedges and add to meat 10 minutes before the end of the cooking time.

Remove the cooked meat, sprinkle with salt, and keep warm. Strain the cooking liquid through a sieve. Mix the flour with the sour cream and use the mixture to thicken the gravy.

Steak with Olives

Ingredients

2 large rib-eye steaks (1lb 5 oz each)

freshly ground pepper

1 onion

4 tbsp vegetable oil

15 pimento-stuffed Spanish olives

3 cups chicken broth

2 tomatoes

salt

1 tbsp all-purpose flour

⅓ cup sour cream

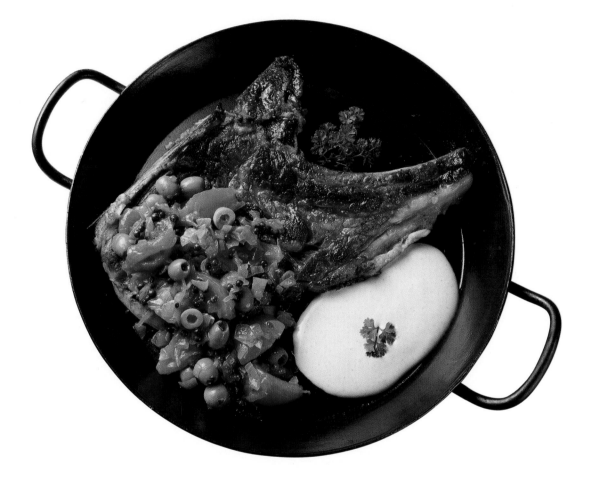

Method

Wash eggplant, cut it lengthwise into finger-thick slices, keeping the slices still attached at one end. Sprinkle the cut sides with salt, and drain in a sieve for 30 minutes. Rinse under cold running water. Pat dry with kitchen paper and arrange in greased oven dish.

Drop the tomatoes briefly in boiling water (do not cook), then plunge into cold water. Skins, core, and slice them.

Peel and chop the garlic. Drain the mozzarella and cut it into thin slices. Insert alternate slices of tomato, mozzarella, and salami into the eggplant. Sprinkle with garlic, drizzle with oil, and place in the oven. Cover with nonstick baking paper.

Sprinkle with parsley before serving.

Ingredients

4 medium eggplant

salt, 8 tomatoes, 6 garlic cloves

7 oz mozzarella, 8 slices salami

6 tbsp olive oil, minced parsley

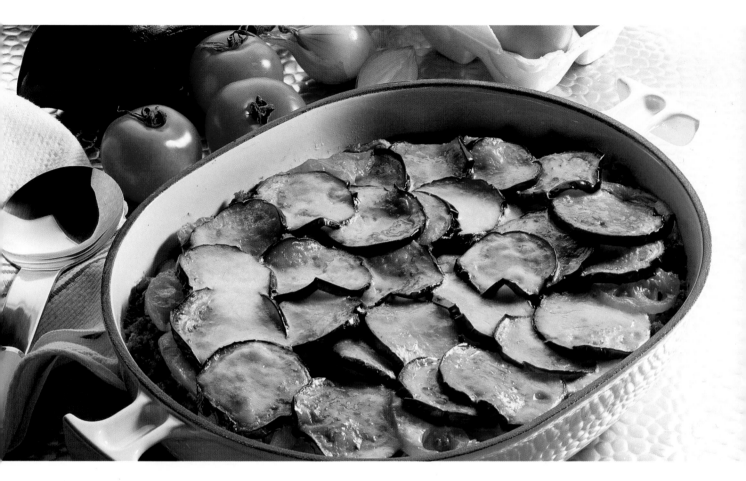

Baked Eggplant

Oven

Conventional oven: 400°F (preheated)

Fan-assisted oven: 375°F (preheated)

Gas oven: Mark 3-4 (preheated)

Baking time: around 50 minutes

Method

Sift the flour and baking powder into a mixing bowl. Add the other ingredients and beat on low speed until well blended, then beat on high speed until smooth. Knead by hand until smooth and elastic. If dough becomes sticky, put in cold place for a while. Roll out dough to 1/8-inch thick, cut out 3-inch circles. Place on a well greased baking sheet and bake in the oven until golden-brown (for temperatures, see opposite). Bake for around 5-7 minutes.

In a saucepan, make a caramel mixture with the butter with the sugar, vanilla, and honey, stirring constantly. Add the heavy cream and stir until it has dissolved into the caramel mixture. Add the almonds, hazelnuts, and cherries. Mix well and bind together. Add the rum extract. use two tablespoons to spoon the mixture over the baked cookies. Return to the oven (for temperatures, see opposite). Baking time 10-12 minutes. Remove from the oven and leave to cool completely.

Heat the couverture chocolate over boiling water in a small pan until smooth and brush on bottom of the cold cookies.

Florentine Cookies

Ingredients

For the dough

1¼ cups all-purpose flour

½ level tsp baking powder

2 tbsp sugar, 2 tsp vanilla sugar

1 egg, 6 tbsp butter

For the topping

3 tbsp butter, ⅓ cup sugar

2 tsp vanilla sugar

2 tbsp honey, ½ cup heavy cream

⅔ cup flaked almonds, ⅔ cup flaked hazelnuts

2 tbsp sliced cocktail cherries

5 drops rum extract

For the frosting

3 oz dark chocolate couverture

Oven

Conventional oven: 400°F (preheated)

Fan-assisted oven: 375°F (preheated)

Gas oven: Mark 3-4 (preheated)

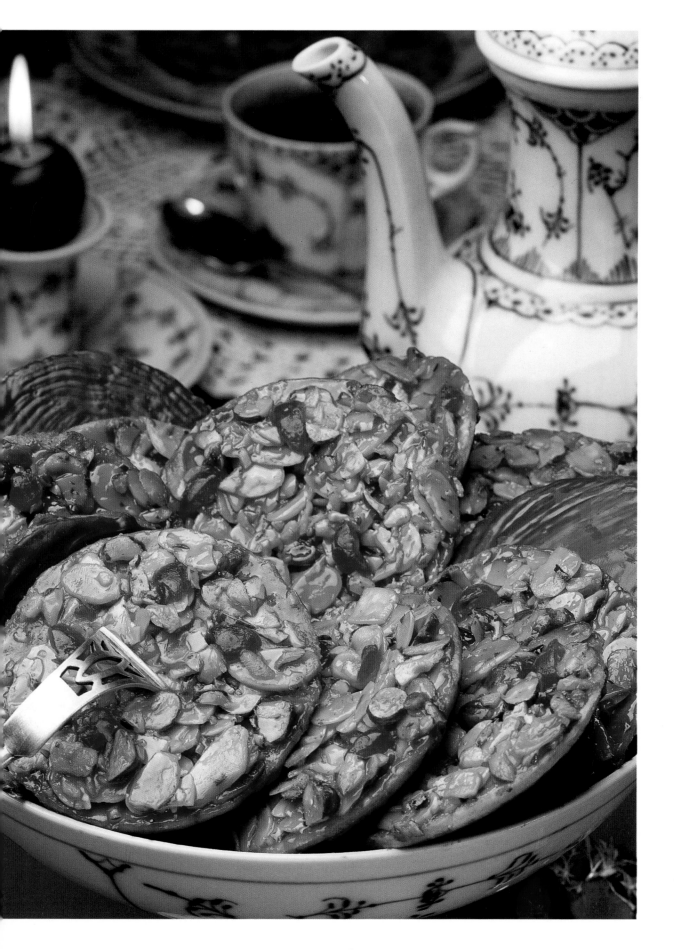

Method

Wash the eggplant, trim the ends, and dice them. Sprinkle with salt and steep

for 10 minutes. Rinse under cold running water and drain. Peel and chop the onion. Slice

the bell peppers in half lengthwise and remove stems and seeds, along with the white

ribs. **Wash** and cut into strips. Wash the zucchini, trim the ends, and cut into thin slices.

Peel and chop the garlic.

Heat the oil in a flameproof casserole or Dutch oven, and cook the vegetables

for 5 minutes, stirring constantly. Add the wine and vinegar, season with salt, pepper,

sugar, and herbs.

Cover the pot and simmer the vegetables for 15-20 minutes.

Mix the tomato paste with the tomato juice, add to vegetables. Add the liquid

seasoning, bring back to the boil, and transfer to a serving bowl.

Ingredients

1 small eggplant, 1 tbsp salt

1 medium onion

1 small red bell pepper

1 small green bell pepper

1 small zucchini

1 garlic clove, 2 tbsp olive oil

2-3 tbsp white wine

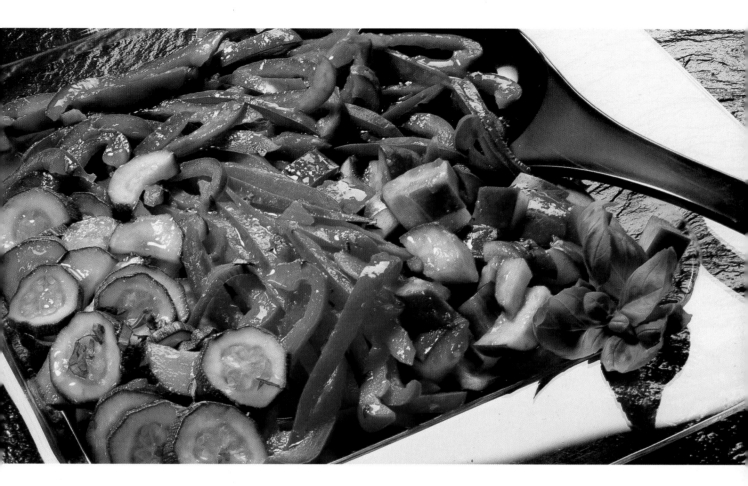

Italian Eggplant and Pepper Stew

2-3 tbsp wine vinegar, salt

freshly ground pepper, sugar

chopped basil

chopped oregano

1 tbsp tomato paste

1½ cup tomato juice, liquid seasoning

tuscany

Method

Heat the oil in a deep skillet. Peel and chop the onion and garlic, and sauté them.

Add the spinach without thawing and a little water. Simmer for 15 minutes, covered.

Season with salt, pepper, and grated nutmeg. Drain and spoon into greased ovenproof dish.

Melt the butter and mix with flour. Heat until golden-brown, stirring constantly. Add the milk and heavy cream, beating well with a whisk. Bring to the boil and cook for 2 minutes. Season with salt and pepper.

Mix one third of the sauce with half the Parmesan cheese. Reserve the rest of cream sauce. Pour half of the cheese sauce over the spinach and use other half to fill the cannelloni (preferably with a piping bag).

Place the filled cannelloni on the spinach and pour the remaining cream sauce over them. Sprinkle with the remaining Parmesan cheese. Dot with butter and place on the center rack of the oven.

Ingredients

1 tbsp vegetable oil, 1 onion

1 garlic clove, 1 lb 5 oz deep-frozen leaf spinach

salt, freshly ground pepper, nutmeg

For the sauce

3 tbsp butter, 3 tbsp all-purpose flour

1¾ cups milk, ½ cup heavy cream

1 cup grated Parmesan cheese

6 cannelloni, butter cut into flakes

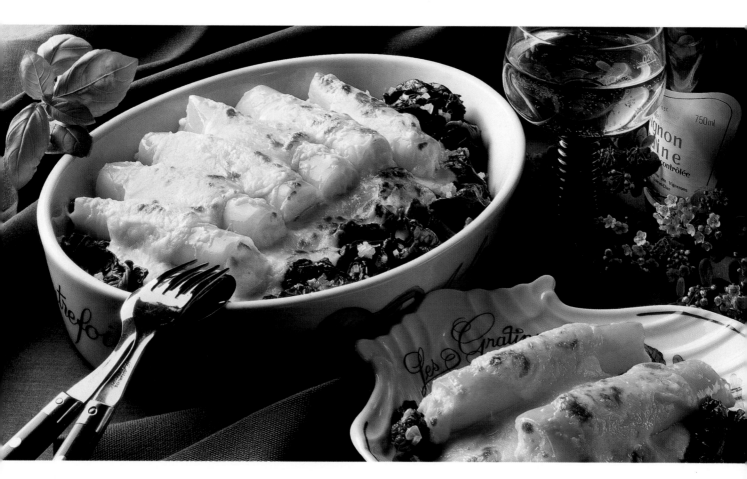

Cannelloni with Leaf Spinach

Oven

Conventional oven: 425°F (preheated)

Fan-assisted oven: 400°F (preheated)

Gas oven: Mark 4-5 (preheated)

Baking time: 20-30 minutes

Serving suggestion

Tomato salad

tuscany

Method

Thaw the puff dough.

Dip the cherry tomatoes briefly in boiling water (do not cook), then plunge them into cold water. Skin and core them and them cut in half lengthwise.

Beat the cheese and eggs together, mix with crème fraîche, and season with pepper and ground nutmeg.

Wash the basil, pat it dry and remove leaves from stalks. Reserve a few leaves and chop the rest.

Rinse four 5-inch diameter fluted pie pans with cold water. Roll out the dough very thinly and transfer to the pans. Sprinkle with basil. Spoon in the tomato-and-cheese mixture.

Place in the oven, and bake first on the bottom shelf then on the center shelf. Sprinkle with the reserved basil.

Tomato Pies with Basil

Ingredients

6 oz phyllo dough, 12 cherry tomatoes

2 tbsp yellow cheese

2 medium eggs

2 tbsp crème fraîche

freshly ground pepper

nutmeg, 1 bunch basil

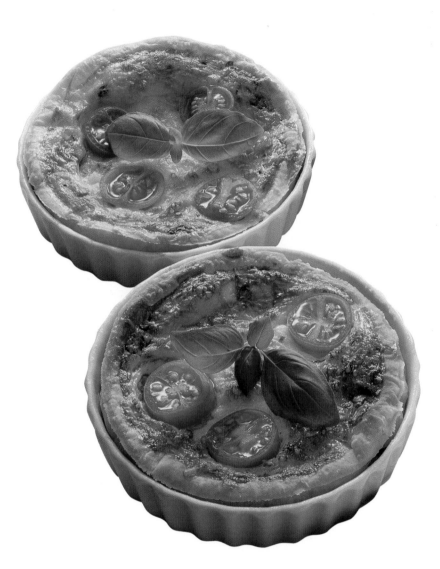

Oven

Conventional oven: 425ºF (preheated)

Fan-assisted oven: 400ºF (preheated)

Gas oven: Mark 4-5 (preheated)

Baking time: 10 minutes

tuscany

Method

Cook the pasta in water with the oil and salt until al dente, according to the package instructions. Drain in a colander and keep warm.

Wash and dry the lemon, peel off a thin strip of rind and reserve. Grate the rest of the rind and reserve it. Cut off the white parts, and divide the lemon into segments. Cut the segments into small pieces, mix with the heavy cream and vodka. Add the strip of rind. **Bring** to the boil and cook for 5 minutes. Add the lemon juice. Return to the boil and cook for another 5 minutes. Season the sauce with salt, pepper, and sugar. Discard the piece of rind.

Mix the cooked pasta with the lemon sauce and grated Parmesan. Place on a serving platter and sprinkle with the grated lemon rind.

Ingredients

1 lb 5 oz tagliatelle (fettuccini), 1 tbsp vegetable oil,

salt

For the sauce

1 untreated lemon

2 cups heavy cream

3-4 tbsp vodka

1 lemon, juice squeezed

salt, freshly ground pepper

sugar, 3 tbsp grated Parmesan cheese

Tagliatelle with Lemon Sauce

Tip

Serve with lettuce leaves or serve the tagliatelle with

lemon sauce as a side-dish with chicken breast or

Vienna schnitzel and mixed green salad

tuscany

Method

Sift the flour into a large mixing bowl, and gradually mix with the yeast. Add the other dough ingredients and beat on low speed until blended. Beat on high speed for 5 minutes until smooth. Leave to rise in a warm place for 10 minutes.

Wash the celery and leeks and chop them. Cut the pepper in half lengthwise and remove the stems, seeds, and white ribs. Wash and cut into thin strips. Peel and chop the onion and garlic. Heat 3 tablespoons of the oil and sauté the celery, leeks, pepper, onion, and garlic for 5 minutes. Season with salt, pepper, and half the dried mixed herbs. Rinse the chicken breast under cold running water, pat dry, and cut into thin strips. Season with salt and pepper. Heat 2 tablespoons of oil and sauté the chicken for 3 minutes, turning frequently. **Add** the soy sauce, stir, and leave to cool. Mix the tomato paste with water, season with salt, pepper, and the rest of the dried mixed herbs. Knead the dough again briefly and roll it out to cover a greased cookie sheet. Spread it with the tomato mixture and cover with vegetables. Wash and core the tomatoes, chop them, and arrange on top of the vegetables. Sprinkle with cheese and place in the oven.

Chicken Pizza

Ingredients

For the pizza dough

¾ cup all-purpose flour, 1 package active dry yeast

1 tsp sugar, 1 level tsp salt

¾ cup warm water, 1 tbsp vegetable oil

For the topping

2 celery stalks

1 leek, 1 red bell pepper

1 onion, 1 garlic clove, 5 tbsp vegetable oil

salt, freshly ground white pepper

½ tsp chopped mixed herbs

14 oz chicken breast fillet, 2 tbsp soy sauce

2 tbsp tomato paste, 2 tomatoes

⅔ cup grated yellow cheese, olive oil

Oven

Conventional oven: 400-425°F (preheated)

Fan-assisted oven: 375-400°F (preheated)

Gas oven: Mark 4 (preheated)

Baking time: around 25 minutes

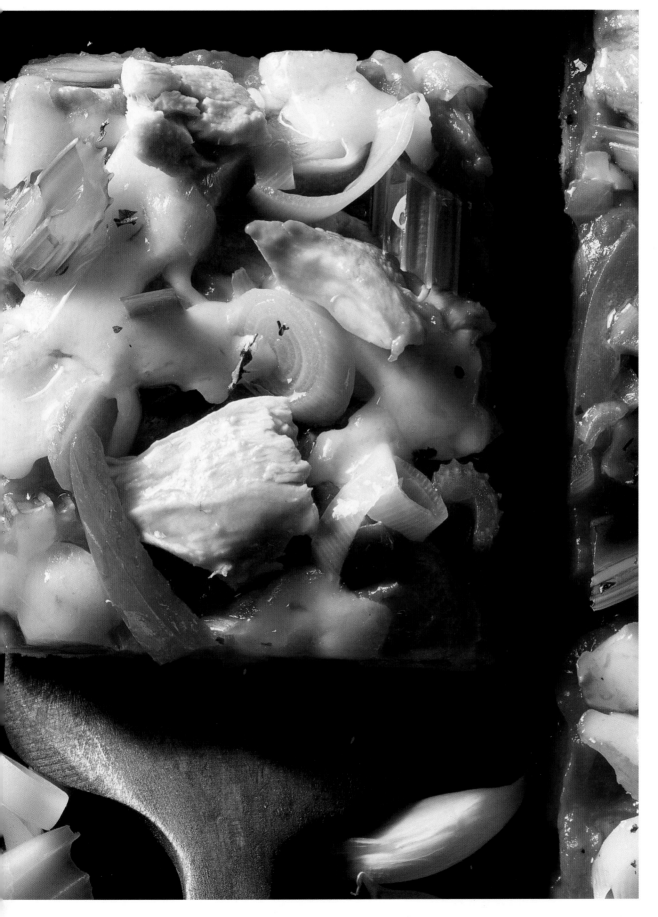

Method

Wash the eggplant, trim the ends, and slice into 1-inch slices. Sprinkle with salt, and steep for 10 minutes. Rinse thoroughly and pat dry with kitchen paper.

Heat the oil in a skillet, brown the strips on both sides, and drain on kitchen paper immediately.

Peel and chop the garlic. Arrange the eggplant, basil leaves, and garlic on a large plate and serve hot or cold.

Ingredients

4 large eggplant

salt, pepper

olive oil

5 fresh basil leaves

Fried Eggplant with Basil

Method

Trim and wash the cauliflower flowerets. Wash and chop the carrots. Shell the beans and wash them. Wash the leeks and cut them into 1/2-inch pieces. Wash and chop the celery. Wash peas.

Melt the butter and sauté the vegetables. Add the broth and season with salt and pepper. **Bring** to the boil and simmer for 20 minutes.

Dip the tomatoes in boiling water (do not cook), then plunge into cold water. Remove the skins and core and chop them. Add them to the soup. Sprinkle the soup with the herbs before serving.

Serving suggestion

Farina dumplings

Country Vegetable Soup

Ingredients

1 cup cauliflower flowerets

2 medium carrots

½ cup fresh green beans

1 leek

1 large celery stick

⅔ shelled cup garden peas

3 tbsp butter

3 cups vegetable broth

salt

freshly ground pepper

2 medium tomatoes

2 tbsp freshly chopped herbs (such as parsley, chervil, and thyme)

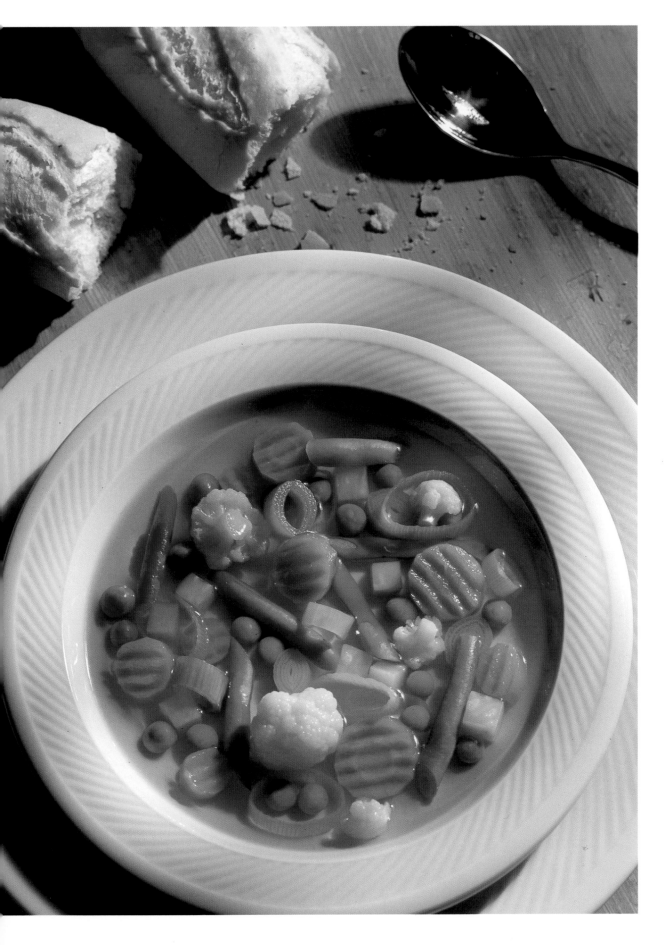

tuscany

Method

Wash the fennel, cut it in half if desired, pat dry, and slice it thinly. Reserve the feathery leaves. Peel and section the oranges. Peel and chop the onion.

Combine the salt, pepper, sugar, vinegar, and oil and pour this over fennel and oranges. Toss lightly. Sprinkle the salad with the pistachio nuts and fennel fronds before serving.

Fennel and Orange Salad

Ingredients

2 fennel bulbs, 2 oranges

1 small red onion, salt

freshly ground pepper, a pinch of sugar

1-2 tbsp white wine vinegar

4 tbsp olive oil

4 tbsp chopped pistachio nuts

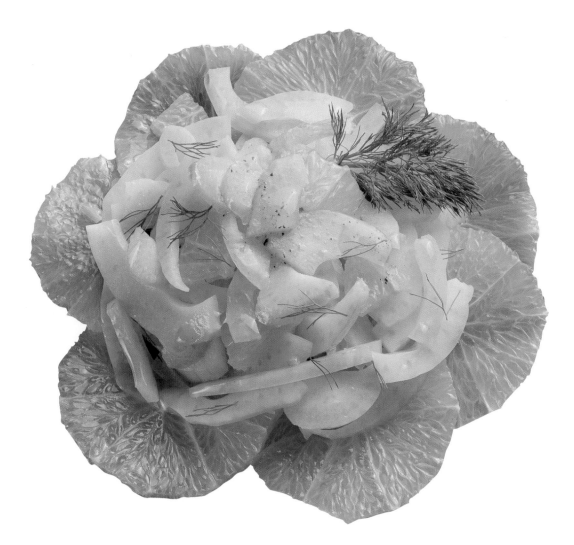

Method

To make the pasta dough, mix the whole-wheat flour, eggs, oil, water, and herbs. Roll the dough into a ball, wrap it in cling film and let it rest for 30 minutes. Roll out thinly on a floured board. Cut it into 2 x 4½ inch rectangles or feed it through a pasta machine. Bring the water to a boil in a large pan with some oil and salt. Cook the pasta sheets for 2 minutes, then plunge them into cold water.

Trim the eggplant and celery. Remove the strings from the thick sticks of celery. Wash and chop the celery and eggplant. Wipe the mushrooms, rinse under cold running water if necessary, and slice them. Peel and chop the onions, heat the oil and sauté them. Add the vegetables and simmer briefly. Peel and chop the garlic. Add the garlic and tomatoes to the vegetables, season with thyme, rosemary, ground coriander, pepper, and salt. Cover and simmer the vegetables for 10 minutes. Leave to cool. Mix the cream cheese and heavy cream until smooth. Wash the basil and pat it dry. Pick the leaves off the stalks, chop them, and add to cheese mixture together with the crushed peppercorns. Season with salt if desired. **Place** a layer of noodles in greased ovenproof dish, and spread them with some of the mixture. Continue with alternate layers of noodles and vegetable mixture, ending with a layer of noodles. Place the dish in the oven.

Ingredients

For the lasagna

2 cups whole-wheat flour , 2 medium eggs, 1 tsp vegetable oil

2-4 tbsp water, ½ tsp Italian mixed herbs, pinch of sweet paprika

freshly ground pepper, 1 level tsp salt, water, a few drops oil

For the filling

3 eggplant, 3 large celery stalks

2 cups chestnut mushrooms, 1 large egg, 1 tbsp vegetable oil

1-2 garlic cloves, 1¾ cups drained canned tomatoes, 1 cup vegetable broth

1 tsp each dried thyme, rosemary, ground coriander, freshly ground pepper, salt

For the topping

10 oz cream cheese, ⅓ cup heavy cream, 1 bunch basil, 1 tsp crushed green peppercorns

salt, freshly ground pepper, 2 level tsp margarine, 3 tbsp grated cheese

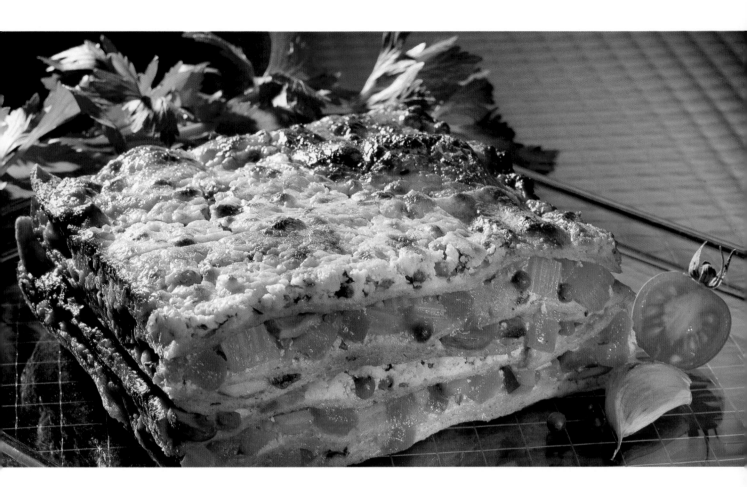

Eggplant Lasagne

Tips

Sprinkle the eggplant slices with salt, leave them to steep for 10-20 minutes, then wipe them with kitchen paper. This will ensure that the eggplant does not absorb too much oil when cooking.

Oven

Conventional oven: 400°F (preheated)

Fan-assisted oven: 375°F (preheated)

Gas oven: Mark 3-4 (preheated)

Baking time: 30 minutes

tuscany

Method

Rinse the rabbit haunches under cold running water then pat dry. Heat the oil in a casserole or Dutch oven and sear the meat all over. Remove the rabbit and season with salt.

Peel the garlic and cocktail onions or shallots.

Place all the ingredients in the pot, and top with the rabbit. Add salt and white wine. Place in the oven.

Ingredients

4 rabbit haunches, ⅓ cup olive oil

salt , 2 garlic cloves

⅓ cup cocktail onion or shallots

⅓ cup green olives, pitted

⅓ cup black olives, pitted

2 sprigs rosemary, 2 sage leaves

2 tbsp green peppercorns, ⅓ cup olive oil

1¾ cups dry white wine

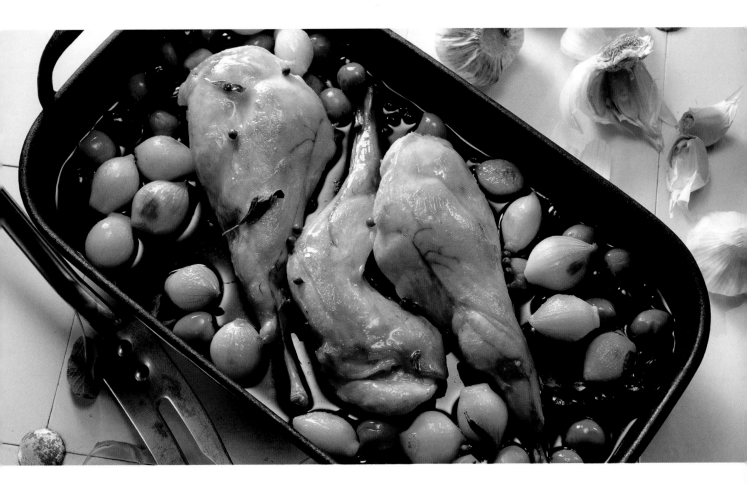

Rabbit Haunches with Olives

Oven

Conventional oven: 400°F (preheated)

Fan-assisted oven: 375°F (preheated)

Gas oven: Mark 3-4 (preheated)

Baking time: 20 minutes

Tip

Serve with Turkish bread (warmed in the oven)

or serve with fresh salad leaves.

tuscany

Method

Wash the tomatoes, pat dry, cut off the top and scoop out the pulp. Sprinkle the insides with salt and pepper.

Remove the mozzarella from its bag, reserving the liquid. Cut it into pieces and mix with the basil.

Mix the mozzarella liquid with olive oil and vinegar. Season with salt and pepper.

Pour this over the cheese mixture, leave it to soak in for a few minutes. Use the mixture to stuff the tomatoes. Garnish with basil leaves.

Italian Stuffed Tomatoes

Ingredients

12 cherry tomatoes, salt

freshly ground pepper

Stuffing

3 packages mozzarella (4 oz each)

5 tbsp chopped fresh basil

5 tbsp mozzarella liquid

8 tbsp olive oil, 6 tbsp balsamic vinegar

salt, freshly ground white pepper

basil leaves

Serving suggestion

Pita or ciabatta.

Tip

Add a peeled, crushed garlic clove

to the marinade.

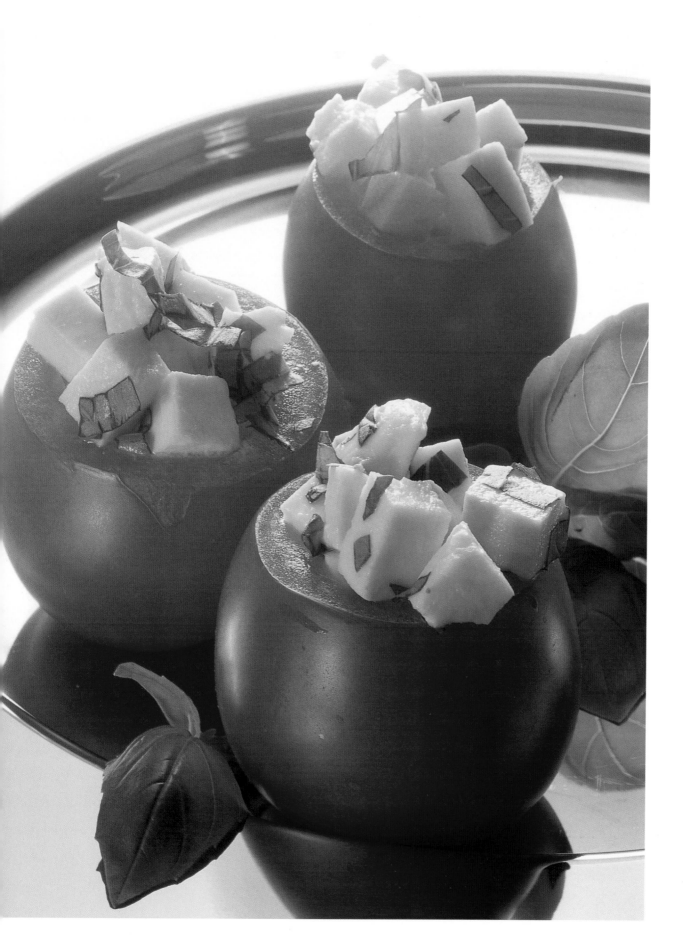

Method

Season the lamb with half the Armagnac, and let it soak overnight. Peel the onion.

Make small slits in the lamb and insert the bayleaves and cloves with tip of knife. Cook the meat in salted water for 30 minutes.

Wash the artichokes, remove the tough outer leaves, trim the stem until it is even with the base, and trim 1 inch off the top leaves. Rub the cut surfaces with the halved lemon.

Cook in salted water for 30 minutes on low heat. Use a spoon to remove the fuzzy choke and any interior leaves that have prickly tips.

Melt 4 teaspoons butter in a pan and sear the lamb on all sides for 2 minutes, or until pink. Place the lamb on the artichokes. Melt 4 tbsp butter in a pan. Slice the pork, sear it, and arrange it over the lamb.

Peel and chop the shallots. Skin and core the tomatoes and chop them. Melt 4 teaspoons butter and sauté the shallots. Add the remaining Armagnac and red wine. Add the tomatoes and reduce the sauce. Stir in the remaining butter. Pour the sauce over the meat and top with mushrooms.

Ingredients

8 lamb sweetbreads (about 3 oz each)

2½ tbsp armagnac

½ tsp chopped thyme

½ tsp chopped sage

1 tbsp minced parsley

7 oz calf's sweetbread

1 onion, 1 bayleaf

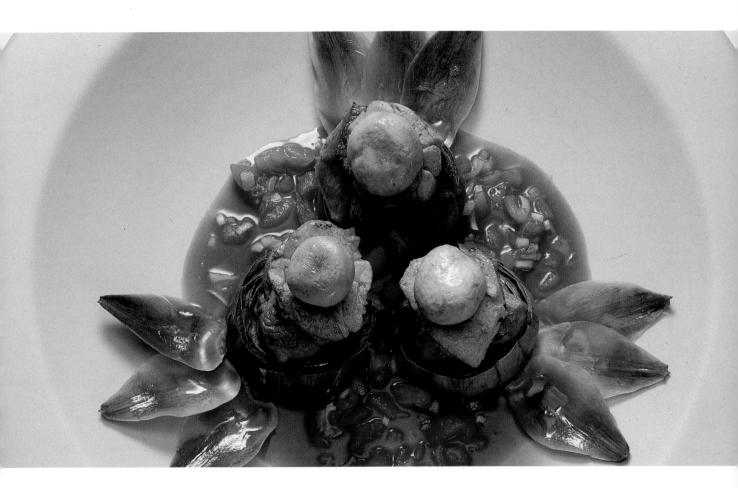

Lamb Sweetbreads with Artichokes

1 clove, salt

8 small artichokes

lemon juice, 5 tbsp butter

2 shallots, 2 tomatoes

4 cl red wine

8 mushroom caps

Method

Sift flour into a large mixing bowl, add the flour, butter, sugar, salt, pepper, and milk. Beat on low speed until blended, then beat on high speed for 5 minutes until smooth. **Add** a little flour if sticky (not too much, dough should remain soft). **Let** rise in a warm place. Briefly knead again. Roll out and place on a greased cookiesheet. **Chop** the onion, bacon, and ham. Heat the oil, fry the bacon, add the onion and ham and sauté for 2-3 minutes. Wash the spinach, carefully remove and discard any bruised leaves. **Place** the wet spinach in a deep pot, cover and cook for 5 minutes. Drain and mix with ham, bacon, and onion. Peel and chop the garlic and add it to the mixture. Season with grated nutmeg and lemon juice. Cover the pizza with the spinach mixture. **Wash** the tomatoes, pat them dry, remove the cores, and slice. Arrange on the spinach, sprinkle with salt, pepper, and marjoram. Sprinkle with the cheese, drizzle with the oil, and place in the oven.

Pizza with Spinach

Ingredients

For the dough

1½ cups all-purpose flour, 6 tbsp burghul

1 package active dry yeast

2 tbsp melted butter

½ tsp sugar, salt, freshly ground pepper

½ cup warm milk

For the topping

1 peeled onion, 3 oz fat bacon

3 oz cooked ham

2 tbsp vegetable oil

8 cups leaf spinach, 2 garlic cloves

pinch of nutmeg, 1 tsp lemon juice

4 beefsteak tomatoes

2 tbsp chopped marjoram

2 cups grated cheeese, 1-2 tbsp olive oil

Oven

Conventional oven: 400-425°F (preheated)

Fan-assisted oven: 375-400°F (preheated)

Gas oven: Mark 4 (preheated)

Baking time: around 20 minutes

Index